Sound Zero | *Valerio Dehò*

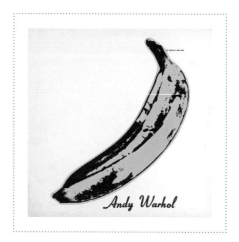

Andy Warhol
The Velvet Underground & Nico
1971
Verve Records, USA
Courtesy Klaus Knop

Top of the Pops | *Valerio Dehò*

The turning point of Pop, as a transversal artistic and musical phenomenon, represented a probably unrepeatable moment in western culture because for the first time the term *popular* became synonymous with *universal*. This on the one hand involved a form of internationalisation of languages and on the other a form of lowering the level of artistic research towards forms that set themselves on a direct plane with the listener and/or observer. The popular in question was something powerfully new because it was unexpected. Art for all probably doesn't exist, but it is a fact that Pop led to a series of operations of familiarisation with the artistic product, something that didn't exist before. A *sound zero* which was a phenomenon of zeroing the neo-avant-gardes with all their utopian and intellectual baggage. Not so much an actual negation as a direct attack on the foundations, on the idea of an elite that chooses for everyone, on the concept that if there is no complexity there is no form of happiness; and also a desire to mistrust the "depth of the depth", as the great artist and musician Alberto Savinio put it.

Obviously the criticisms made of this revolution were all in function of an ideological assault on capitalism. Pop's adherence to reality – including social and economic – was seen as a sign of surrender. It wasn't, although Warhol's cynicism was certainly not interpreted in a paradoxical key, as an artist, but as an apologia for the system. But the question is a different one. If everything is goods, let them at least be quality goods. Pop Art certainly succeeded in creating a form of hyperbole of the object and consumption. It did this simply by choosing, selecting from reality the images that seemed most suitable and then zooming in on them. This way of entering into contact with reality is, not at random, a well known photographic technique called blow up, which extraordinarily became a metaphor in Antonioni's film masterpiece of the same name, and which moreover implies a mechanical movement in which the subject enters into the object. The critical function is reduced and concealed, favouring a frontal view, immediate and direct, the whole difference lying in the

hidden, underlying concept.

Infinite reduction to the absurd in this way the singularity of the observer or listener is put into brackets precisely by the deceitful form of success and pleasure. Everybody likes it, so it's inevitable that you'll like it too. So the world was enlivened by cartoon characters and extra large reproductions of everyday objects such as a vegetable soup can or a box of detergent. The important thing was hyperbole, a rhetorical figure of that which is large, standing for something else; whereas in pop culture it is large and nothing else. This out of scale aspect threw a whole reference system into a crisis. Big is beautiful because everything becomes a poster, a billboard, the element of an unstoppable communication. Oversized and with limitless repeatability: these were the two watchwords to keep always in mind. Oldenburg's gigantesque objects are threats in their isotopic power, but at the same time they end up by assuming the role of toys for budding Titans. The rule is simple: if big is beautiful then very big is very beautiful.

Size is something proper to the genetics of the consumer society, which in the 1960's was beginning to expand all over the planet. Today, 2006, we know that's how it is, know that we could flit from one shopping centre to the next and make the Grand Tour of the global market, seeing and experiencing the same things and sensations. All that's needed is the desire and the money. Everything comes back to itself, also because in the meantime artistic metaphors became reality. The very advertising of consumer objects is often done by mega representations of the product, sometimes three-dimensional. Super tigers to put in your tank, chubby cans of German beer or of energising red bull, toilet rolls as big as houses: it all contributes to rendering the market object a synthesis of artistic ambitions. The example of a category of goods which offers itself to aesthetics as a mediator towards art. Beautiful=big, it seems like kids' stuff, even if there is an odour of death that can be kept at bay only with perfumed paper tissues. Immense or mass reproduced, art is as simple as the philosophy of the supermarket, as Andy Warhol demonstrated with the 100 Marilyn Monroes and Liz Taylors.

So everything is reproducible, and indeed importance is decreed by size or the number of replicas. In this inversion of values a powerful and unstoppable revolution is actuated. The avant-gardes seek utopia in order to bring culture and awareness to the people. The Prometheus syndrome had enveloped the magnificent gestures of Fluxus (first Festival 1962, in Wiesbaden) and of the poetic-artistic neo-avant-gardes, but it's clear that the Pop phenomenon subsumed everything in a world vision as serene as it was false,

as true as it was chilling. It's not that art didn't assume any responsibility, didn't venture onto critical terrain. Rather it chose a language that was everybody's and for everybody. At the same time music sought the same thing. Afflicted by too much incomprehensible and elitist experimentation it aimed at a plane of planetary, easy-listening communication, like every hit parade queen.

Deviation was worn out in this, and differences opened up which nobody wanted to fill any more. An art in harmony with the times, happy enough, stupid enough, and intelligent because it offered to mediate between high and low culture, almost as if it were normal and natural to do so. And here at last the pages of film magazines and printed paper opened up. A *ye ye* generation made itself heard, perhaps even louder than its own voice and beyond its responsibilities. Yet it happened; but why?

Maybe because by that time the Informal had saturated every possible space and filled art with doodles that were, to be frank, increasingly empty. The perennial defects when the artist is too much the creator, too much God. The artist in his little room who, taken over by a dark and maternal divinity, creates masterpieces. The (umpteenth) age of romanticism sank away, also under the blows already landed by New Dada and the scientism avant-gardes such as the German Zero Group and, more familiar in Italy, the N and T, the legendary Padua-Milan axis. It is clear that navel contemplating couldn't last for ever. Too much romantic emphasis, but also repetition of those excesses of "pictorial values" that had led the night flight of *art autre* into a mortal stall. Form, material, sign, colour had become a quadruple divinity which the young generation, who'd already decided to air the rooms of art, were no longer disposed to worship. Why stay within the enclosure of art when outside you only had to go into a supermarket for a change of air! American optimism needed confirmation, needed Elvis ready to shoot in defence of the country's frontiers and free trade; and it mattered little that Warhol's icons included electric chairs and Mansfield's little dogs somewhat

slammed onto the asphalt. Consumerism for everybody needed the hyperbolic certainty that objects are eternal. Even if they are consumed or explode like soap bubbles, they are eternal because they are reproducible to infinity. That was the new concept. *Sub specie aeternitatis* nothing exists, no sense in deluding yourself. The only possible aggression against time remained the continual and ceaseless replica. Thus with the techniques, which were increasingly industrial. Enough of materic brushstrokes and *alte paste*: viva colour *à plat*, laid on with care and diligence. Viva screens, as if it were typographical reproduction, and viva silkscreen printing which continues producing sample prints where other techniques, certainly nobler, would be worn out.

Clearly the result is a world philosophy of happy, absolutely not acritical acceptance of reality. This was perhaps the only way to clear the sandbanks of the post-war period, the arrhythmia of realism and its lies, or the intralinguistic heights of the Informal, dark matter swimming around in the depths of the painter's eye. Whereas the matter became increasingly grey, which is to say cerebral, and painting declined into forms of ever greater conceptualisation. It isn't important to do a painting or a sculpture well. Warhol skipped the *out of range,* and the error become quality in the best Dada tradition. Cinema, music and television were on the same plane as the other arts. And the pop artists did all this, living in the universe of communication, of tele-dependence. From Warhol to Schifano the intentions altered slightly in the sense that Europeans are always less optimistic than Americans. But for the rest the icons are similar. The painting is fast and furious, and graphic production is copious because art must be for everyone and cost little. Already in the early phase the Americans made print runs to finance the Europeans' impoverished exhibitions, as happened in Ferrara in 1975. Often unlimited print runs, like those of Beuys, in spite of his being on the other side of the barricade and dreamed of other things, other utopias, such as a free university for free people. The pop dream sought only happiness and pointed out the shortest road to achieving it.

In A Gadda Da Vida

It was a piece with an original and still incomprehensible title that gave meaning – not only musical – to the progressive cultural slide towards areas of experience between music, religion and psychedelia. Recorded in 1968, it's an acid rock song that occupies the entire B side of the first LP by Iron Butterfly, the group led by singer and keyboards man Doug Ingle. It has always been said that the original title should have been "In the Garden of Eden", but in the post-production phases Ingle changed the title to "In-a gadda-da-vida", apparently a phrase enunciated under the influence of LSD. Thus the legend. But it actually appears that the story was quite different, since drummer Ron Bushy later revealed that it was simply a communications distortion. While listening to the piece on the recording studio headphones he didn't understand the original title, which was then distorted into the one that became so famous. And that's the origin of the myth. In this decision there is also an application of the surrealist method of the *cadavre exquis* and in any case the paradoxical logic of Duchamp which rendered the Random a choice.

Moreover, this celebrated song was very long, absolutely new in those years: 17 minutes of uninterrupted music, extraordinary solos, memorable duets and an incessant, continual sound-rhythm fabric. The piece has since taken on special importance because, with Blue Cheer and Steppenwolf, it marks the point at which psychedelia gave birth to heavy metal and subsequently to other comets such as Led Zeppelin.

On the cover two great reddish bubbles stand out above and behind the group who are on stage playing. The guiding image of psychedelia is liquid, a liquid at the threshold of the gaseous which is deformed under the thrust of internal pressures, of a molecular instability which shatters the colours, mixes them into continually new shades and forms. A deformation that derives from the vision induced by drugs and hallucinogens, which had become a parameter of life and awareness. "Psychedelia was a phenomenon as important to rock as the Greenwich Village pacifist protest or the Berkeley Movement. One may say that drugs had the same role in 60's rock as sex had in 50's rock'n'roll."

(Piero Scaruffi) As a continuation of beat culture, which in turn had been influenced by Aldous Huxley's insights, psychedelia was an extraordinary turning point not only in music. The influence arrived in Greenwich Village with Andy Warhol and at La Honda with Ken Kesey. And not only in the field of theatre and choreography but also and above all with light shows, this to such an extent that the term psychedelic is still used to denote highly coloured lighting effects, from the stroboscopic to the explosion of oily materials in compounds that slow down their dynamics.

The art world metabolised the new phenomenon, especially from the point of view of compositional elements, the prevalence of curvilinear tension and optical effects based on the deformation of habitual perception. The influence of not only Huxley's *The Doors of Perception* but also and above all of correlated oriental philosophies were blended into the search for light which, essentially, is knowledge in its form of illumination. Didn't Jack Kerouac entitle one of his books *Satori in Paris?* The liberation of consciousness became the parameter of a freedom to be manifested in all ways and all fashions. Hypnotic, very gentle, hammering, disorienting, highly coloured, involving and so forth, psychedelia experienced as a state of awareness, as flow, probably found interpretation, though certainly cooler, in artists like Mario Schifano and Harloff, and partially in Jasper Johns and Robert Indiana. Different and overflowing were the increasingly spectacular choreographies linked to the stage, with the creation of phantasmagoric machines and collective mirages.

Moreover, art was going through a widespread if not intense optical period, closely correlated with para-scientific if not wholly scientific research. It's clear that Duchamp's Rotoreliefs were still everybody's example and reference. Also in this case, hypnosis, repetition, getting outside the self through contemplation of the great rotating discs were the premise for a state of awareness that sank into the Id, freeing itself from the control of reason. But art did not embrace, except episodically, these indications of an abstract psychedelia, pure perception without consciousness. In this sense it is closer to the ecstatic effects, the pictorial mysticism of Rothko, or the vibrating quality of Ad Reinardt's colours. For the rest, preference went to iconic declinations, in many ways akin to late surrealism (or to an actual return) which in turn, and not by chance, was linked to drug experiences already present in the European artistic avant-gardes of the first two decades of the century.

This remained the fundamental matrix to which everything returned, whereas the pop aesthetic aimed at shifting the question onto a plane of expressing contents and of a light imagination (and everything related thereto) without heavy symbolisations. A culture without false bottoms, without special missions, but not easy, a dramatic culture even, which always and in any case belonged to a vital flow. Acknowledging the need to project beyond its own awareness, to let itself be soothed by images and not to seek their secret relationship.

Where the Streets have no Name

Reality not as representation but as participation. So as early as the late 70's, when important phenomena such as graffitism appeared, it was at once clear that, in origin, pop culture and what young people were bringing into the streets and subways were blood relations. Meanwhile it was the assertion of a strongly metropolitan culture. Not only did the places belong to the social life of the big city: only in crowded spaces where thousands of people passed daily did that frontier form of artistic communication – writing – seek an outlet. An innovative current that took art out of the galleries and museums, using as a support anything that came up along the way. From urban walls to railway wagons and subway trains, graffitism sought and found direct contact with the public. It's the "masses" that interest the young who still today challenge the police or tackle acrobatic locations. The whole art system, as ridiculed by Tom Wolf, is bypassed and therefore held to be useless or at least uninteresting.

Keith Haring is certainly the icon that best represents the whole group. Steered into the world of comics and cartoons by his father who was a film animator, he studied Mark Tobey, Zen and Paul Klee; he loved the Art Brut discovered by Dubuffet and began to synthesise his universe which mixes childlike art with the idea of a widespread painting, Pollock's *all over,* which he had always admired. Haring is truly the epitome of a genuinely popular art which never saw any problems about living on the outskirts and wanted only to be nourished by the eyes of the public, the whole public, even the casual public generally excluded from the appreciation of art. After moving to New York he was drawn towards beat culture, especially William Burroughs, but also towards the prophet of LSD and psychedelia, Timothy Leary, who has influenced more than one generation of artists.

The presuppositions of Pop all return forcefully, and also with an existentialist charge, very hard and terminal, as in the case of Basquiat. Being popular meant above all opening up to society and communicating. Haring's white chalk works on advertising placards are a repertoire of radiant children, sex, flying saucers,

cartoons and much else, but above all they are a message of energy and happiness. The very spreading of his art gadgets, as with other graffitists, was an extension of what he created on the streets. The message was always to bring art to the people, nothing else.

Certainly the private lives of many of these artists seem to give the lie to this general happiness, this need to be with others. Of course it's a contradiction, but it is so in an exemplary, positive way, as a driving force for other actions, other feelings and certainly not as the impossibility of action. Drugs, AIDS, suicides are not dead end streets but perhaps a price to pay for the great energy expended. Peripheral art, then, although a great dealer like Tony Shafrazi was one of the first to notice Haring's talent and did what he knew how to do.

The streets today, however, are still open and without names, the rebels buried and idolised by a market that awaits only heroes to exploit. But street works remain and proceed, living on today in street art, a phenomenon that now globalises art without claims to degree of importance or artificial distinction between the various levels of culture. A culture that possesses the immediacy of spontaneity, that glorifies the dusty silences of the city limits, overflowing urbanisation against a definitively forgotten nature. But above all an art that is close to youth, to their needs and fears, their uncertainties. It's an art which accepts no grammar and does not want to create one, but which has rules and behaviours. *Street art* is a musical and visual fabric of "normal" days that are often repeated too often. The expectation of an immense rave party that zeroes day and night, interior perception from external which succeeds in overcoming the limitations of time and physical resistance. But in all this there lives the infinitesimal and fragmentary reality refracted in little personal stories. Personal and universal converge in a common synthesis, in an extended language that does not refute but exalts the individual. The artists find a synthesis between contemporary iconographic decoration and the definition of an aesthetic sphere in which art and life proceed in step. Stories of cartoons and films told by ordinary people, complex but elementary events, desperate and weightless lives. No tragic dimension is evident: everything is human in a world of streets without a name, where God is a palindrome of Dog and both are signs of a lesser universe.

TOP

THE

POPS

This is Pop | *How and why Andy Warhol had already understood today's pop music thirty years ago.*

Fabio De Luca | Is there an element of pop-art, a sliver of Warhol's lucid vision, in today's pop music? There sure is. And it isn't limited to the fact – as everyone has learnt to repeat, even editors of newspaper entertainment sections – that for two decades the spread of cheap means of production (a whole recording studio on a laptop!) and especially of distribution (from independent labels' lists to mp3s, legal and illegal, on the web) have made Warhol's famous "fifteen minutes of celebrity" a reality within everyone's reach to such an extent that it even sounds trite today. Take a glance at You Tube (www.youtube.com), an infinite warehouse of pop television detritus, and search "White Town". White Town is (was?) an English techno-pop musician of Indian origin – real name Jyoti Mishra – who in 1997 hit amazing planetary success with a piece called "Your Woman". For two weeks nobody talked about anything else, then he disappeared into an oblivion that may unexaggeratedly be defined as severe and definitive. Warhol would've appreciated him, would've loved the parabola. But we must go beyond this. In times when the fifteen minutes are almost a genetic endowment or constitutional right, Warhol's *boutade* requires constant and precise updates. *"In the future everyone will have fifteen minutes of anonymity,"* is the ironic comment by Bolognese blogger Inkiostro (inkiostro.splinder.com). While the musician-artist Momus (imomus.livejournal.com) intuits that *"in the future we'll all be famous for fifteen people"*. Here too Warhol would have nodded assent to such a splendid updating. Niche consumption, digital distribution and on demand availability of music products are taking us precisely there. The most innovative pop music circuits are already running on the "famous for fifteen people" principle. Micro-phenomena created by bloggers' chain-letters (like New York band Clap Your Hands Say Yeah), musical genres which are so dot-like that they can exist and survive only within a ring of special sites, nano-stars who are unknown outside their tight circle of admirers.

And old style stardom? And the pop stars of the good hit parades of long ago? Obviously they're still around. But their position at the top is increasingly threatened and called into question. Crushed between the rise of new

markets with new rules and requirements (the far east is near) and an increasingly greater mass distribution that transforms them into the very essence of pop – pure chorus, mobile phone ring tone – the old style pop stars are staggering, their vision gets clouded, the image dances jerkily like in the old Max Headroom special effect of tele-ectoplasm. For the moment they're still capitalising while they can, but tomorrow? Also because: once transformed into little sequences of bits wandering the web, all pop stars are equal, aren't they? Might this be the real mp3 revolution? And Warhol comes back to mind. What Warhol loved about popular consumption was its role as leveller, as lowest common denominator, as point of contact (maybe the only one) between social classes. "The President drinks Coke, Liz Taylor drinks Coke, and just think, you can drink it too. A Coke is a Coke and no amount of money can get you a Coke better than the one the bum on the corner is drinking. All the Cokes are the same" (from a quote almost as famous as the fifteen minutes one). Once transformed into data packages, into the trill of a ring tone, what difference is there between Madonna and Tiziano Ferro? Between the Rolling Stones and the White Stripes? All the same, like the cans of Coca Cola. A horizontal vision which, moreover, has been part of the DJ world for some time. Those for whom the laptop really is an extension of their fingers, for whom every new hit is just a doll to take apart and then to recombine its pieces with pieces of other dolls until an imaginary pop star is put together. As in the subculture of the "mash-up" or of "bastard pop" where the voice of Blondie's Debbie Harry slides over the organ of the Doors, and Destiny's Child clutch onto the "*sdran-dran-dran*" of Nirvana's

Smells Like Teen Spirit. And even farther: an English guy called Osymyso has composed a fifteen minute symphony entitled *Intro-Inspection* by hooking up the intros (just the first few seconds) of 101 famous pop and rock songs. Warhol would've gone crazy for it.

Warhol who was not a musician but who had an "overall vision" comparable to that of today's DJ-producers. Who in 1965 became manager of the Velvet Underground, the band that represents the irreparable loss of rock'n'roll's innocence. Their first record (with the celebrated "banana" on the cover, designed by Warhol himself) is perfectly summed up in Brian Eno's words: "when it came out very few people noticed it or bought it, but practically everybody who bought it was inspired to set up a band." And the rock'n'roll essence of the Velvets is involuntarily reunited with that of their discoverer and mentor in the boxed set that came out about ten years ago. An attempt to put onto CD all the recordings ever made by the Velvet Underground, *Peel Slowly And See* offers four practically identical demo versions, one after the other, of *Venus In Furs*, and nine successive takes of *All Tomorrow's Parties*, each one interrupted by some technical difficulty. Like seeing on a black and white TV screen four xerocopies of the same portrait of Marilyn Monroe, one next to the other, each turned into a different nuance of grey. As usual everything revolves around reproducibility and consumption. And even around the minimal variations and the "meaning" they might have, as if actually wanting us to find it: watching a couple of hours of a young man's real time sleep, or "finding the differences" between four more or less identical takes of the same song.

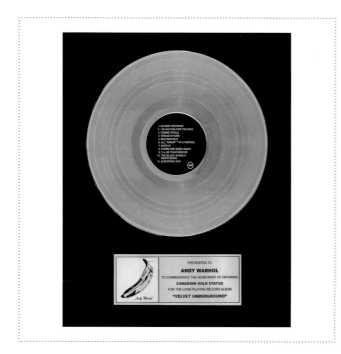

Andy Warhol
The Velvet Undergound & Nico
Gold Disc
Courtesy Klaus Knop

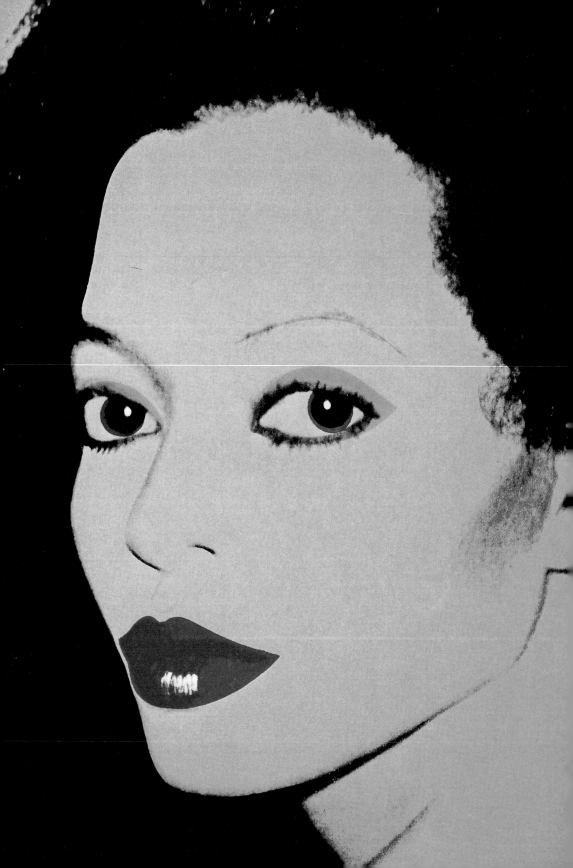

Andy Warhol

(Andrew Warhola) was born on 6th August 1928 in Pittsburgh (USA). During 1934-35 he collected
lm stars' autographs. At the age of 9 he had a nervous breakdown during the summer holidays. When
was 14 he enrolled at the Carnegie Institute of Technology in his home town. Between 1948 and 1949
worked as a graphic designer and changed his surname to "Warhol". In 1950 he bought his first TV
t. In 1954 he received a prize of excellence from the American Institute of Graphic Arts and in
58 bought Jasper Johns' drawing "Light Bull". He started painting comic strip characters on canvas
1960, and the following year saw Roy Lichtenstein's exhibition at Leo Castelli's in New York. In
62 he abandoned the world of comics and began painting his most famous series, such as Campbell's
up Cans, Disasters, Do it Yourselfs, Elvises, and Marilyns. In the same year he took part in the
hibition "The New Realists". In 1963 he moved into the studio that would become the celebrated
ctory. In 1964 he made, among others, the film "Empire". In 1966 the German actress and singer Nico
hrista Paffgen), International Velvet and Eric Emerson entered into the activities of the Factory,
d in the same year Warhol produced and managed the Velvet Underground's concerts. He did 40 record
vers for singers and groups such as Donna Summer and the Rolling Stones. He died in 1987.

Courtesy Klaus Knop

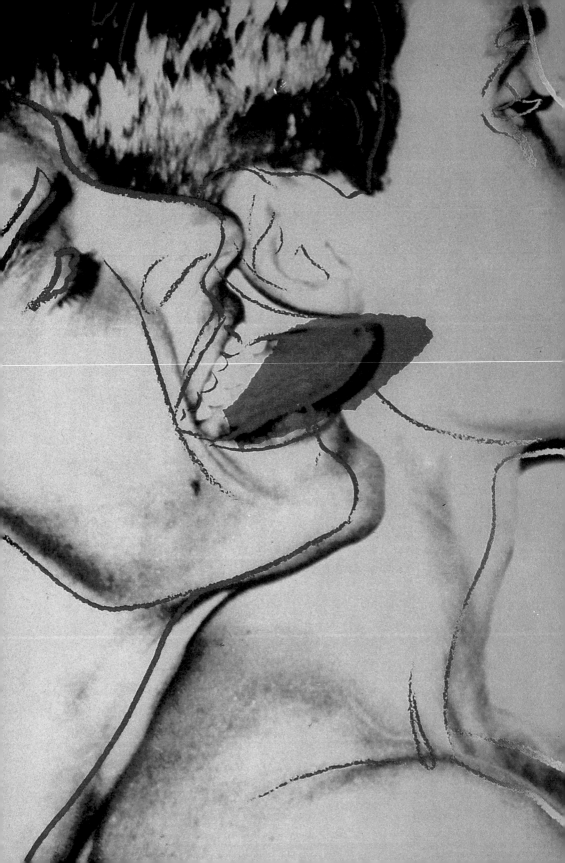

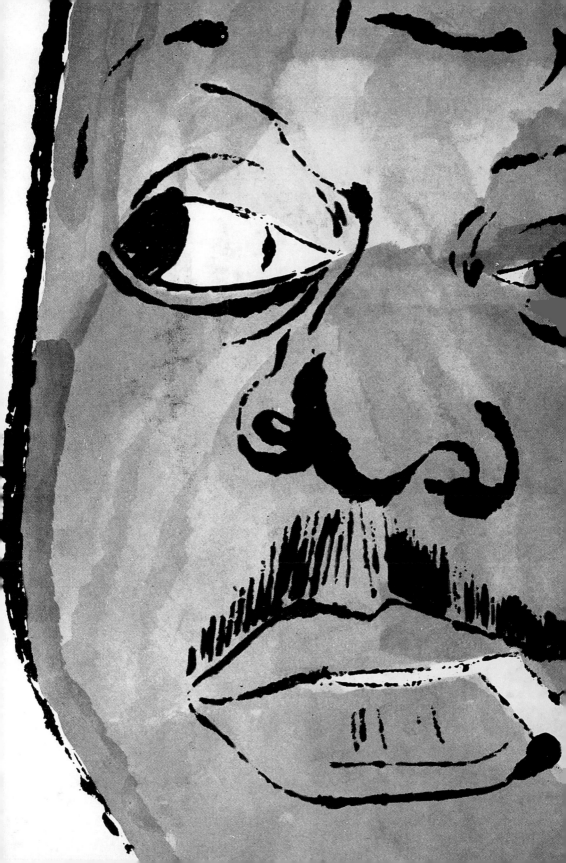

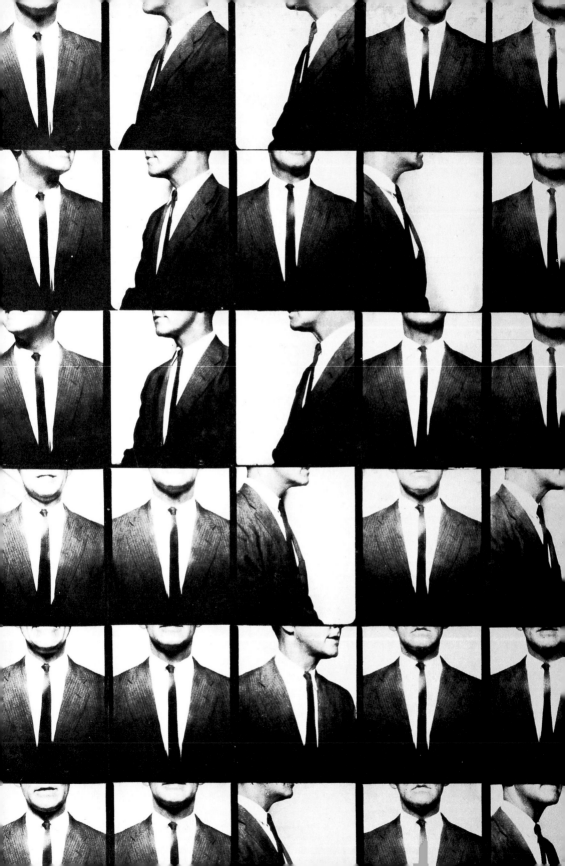

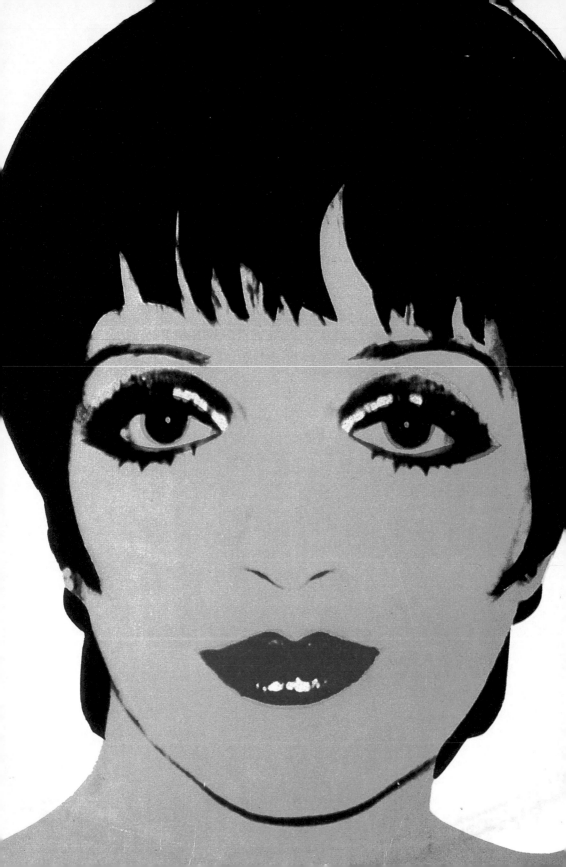

Kenny Burrell
Liberty Records
1957
Printed in U.S.A.

Count Basie and his Orchestra
1955
TMKS, Radio Corporation of America

Arturo Toscanini
Rossini - William Tell Overture and
Semiramide Overture
1953
RCA

The Congregation
Johnny Griffin
1957
Blue Note Records, New York

Blu Lights Volume 1
Kenny Burrell
1958
Liberty Records INC

Blu Lights Volume 2
Kenny Burrell
1958
Liberty Records INC

Cool Gabriel
Candoli, De Risi, Glow, Sherman, Stratton,
Sunkel, Travis
1956
RCA

I'm still swinging
The Joe Newmann Octet
1957
RCA

Trombone by Three
Jay Jay Johnson Kai Winding Bennie Green
Prestige # 4
Design Reid Miles
1956
GEM Albums, Inc., N.Y.

Both Feet in the Groove
Artie Shaw and his Orchestra
1956
RCA

White Light/White Heat
The Velvet Underground
1968
Verve Records

Prokofiev
Alexander Nevsky – cantata, op. 78
1949
Columbia Records Inc

Andy Warhol's Index Book
A Black Star Book
Random House
1967

Tennessee Williams
Reading from The Glass Menagerie,
The Yellow Bird and Five Poems
4th Printing 1960
Caedom

The Nation's Nightmare
A new kind of journalism
1951
CBS Radio Network

The Story of Moondoog
Moondoog
1957
Prestige Records

Thelonius Monk
1954
Prestige Records

The Painter
Paul Anka
1976
United Artists Music and Records, USA

Silk Electric
Diana Ross
1982
RCA

Live at Carnegie Hall
Liza Minnelli
1981
Liza Minnelli, Printed in USA

Emotions
Billy Squier
1982
EMI

Menlove Ave
John Lennon
1986
EMI

Made in Spain
Miguel Bosé
1983
CBS

The Joke
Walter Steding and the Dragon People
1980
Earhole Productions

Aretha
Aretha Franklin
1986
Artista Records, New York

Emotional Tattoo
The Rolling Stones
1982
Pathé Marconi EMI Studios Paris 1980, Musicland
studios München 1974

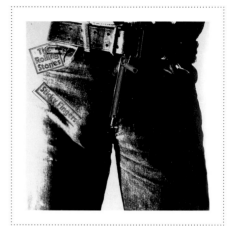

Sticky Fingers
The Rolling Stones
1971
EMI

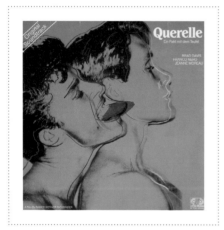

Querelle – Ein Pakt mit dem Teufel
Original Sound Track
1982
Teledec "Telefunken Decca"

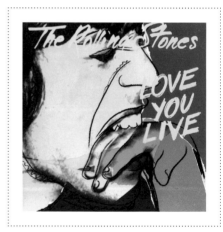

Love You Live
The Rolling Stones
1977
Rolling Stones Records, USA

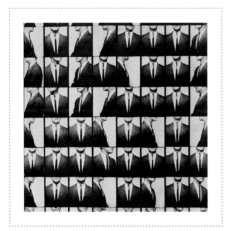

This is John Wallowitch
John Wallowitch
1964
Serenus Records, New York

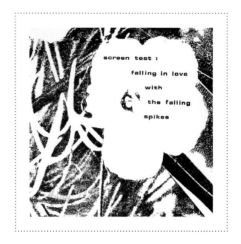

screen test:
falling in love with the falling spikes
The Velvet Underground
1985
Shining Star Records

The Academy in Peril
John Cale
1972
Reprise Records/Warner Bros records, USA

Soul Vacation
The Rats & Star
1983
EPIC/SONY Inc

Robert Rauschenberg
Speaking in Tongues
Talking Heads
1983
Sire Records Company/Warner Bros. Music
Courtesy Klaus Knop

Matthias Schönweger

Born near Merano in 1949, he lives and works both in and out of town. Active in literary-
tistic circles he likes to go beyond the boundaries of the classic divisions between cultural
nres. An enthusiastic explorer and researcher in various fields, he finds answers to topical
estions in his rich treasure of objects: he creates installations, performances of images and
rds, music and dance. He gives artistic form to public places, shop windows and abandoned military
nkers, at his SmartGallery in Merano's Vicolo Steinach and various other museums of his in constant
olution. Several publications have accompanied his works: "Türe zu!" (Schönweger), "FlügelVerleih",
eite an Seite", "von Wegen", "wie Gott sei schuf", 2006 (all published by Edition Raetia Bolzano),
on und zu Peter und Paul", 2005 (Studienverlag, Innsbruck).

Soundtrack with record player
2006
installation and performance
Courtesy of the artist

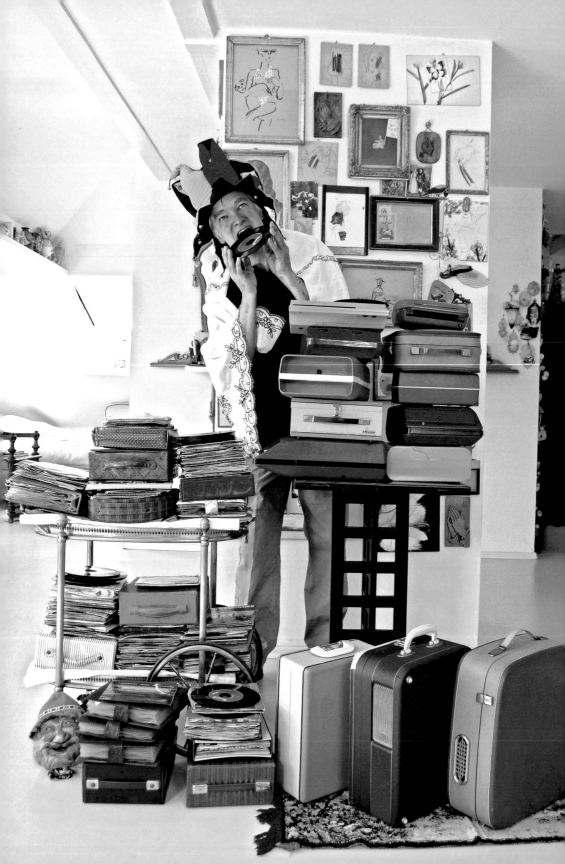

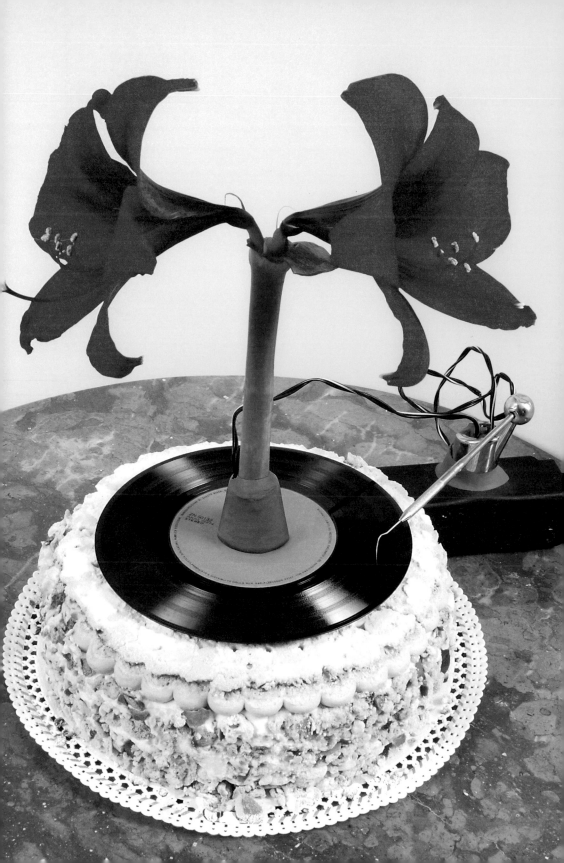

• Robert Gligorov

Born 1960 in Kriva Palanka, Macedonia, he lives and works in Milan. His artistic creation is expressed through photography and the new media and his work is exhibited at the most important European galleries. In 1999 he took part with "Babe's Legend" in the Melbourne Biennial "Signs of live". His photos are striking for their unexpected man/animal/plant composition that sends shivers down the spine. Themes central to his work are sexuality and the search for identity, as in the exhibition "In the Garden of Eros" at the Palacio de Ramblas, Barcelona, and "Supermodel", "Identity and Transformation", in Trieste at the Galleria LipanjePuntin, 2000. Brescia Photography Biennial, Museum Kem Damy, Brescia, 2002, "Desire", Galleria d'Arte Modena, Bologna, 2002, "Melting Pop", Palazz delle Papesse, Siena, Italy; Castello di Masnago Varese, Italy, 2003. Underground station Mater Dei, Naples, a permanent work, curator A.B. Oliva, 2003.

Gramophone Amarillis
2003
lambda print on aluminium
different sizes
Courtesy Galleria Pack, Milano

Il codice del Pop
2001
binded LP vinyl albums' covers
different sizes
Courtesy Galleria Pack, Milano

Piero Gilardi

Was born in Turin in 1943 and had his first one man show – "Macchine per il futuro" (Machines for the Future) – in 1963. In 1965 he exhibited his first expanded polyurethane works in European galleries such as Sperone in Turin and Sonnabend in Paris. He participated in international movements such as Land Art and Antiform Art. In 1969 he began a long period of political militancy which, until the early 80's, resulted in collective creativity experiences in the outer suburbs of the world's cities and among emarginated cultures. Since 1985 he has been working on new technologies with international projects such as the Ixiana project at the Parc de la Villette in Paris. He promoted the slab symposium in Turin and numerous study congresses on new media.

Tappeto Natura
1967
expanded polyurethane
160 x 150 cm
Courtesy Collection Donato Rosa, Napoli

- Franco Angeli

Was born in Rome in 1935 and died there in 1988. He had his first solo show at the gallery La Salita in 1960 and was travelling companion of Schifano, Lo Savio and Festa, forming the so-named "Piazza del Popolo School". In 1963 he exhibited at the gallery La Tartaruga: paintings with enlarged symbols of the swastika, the Capitoline She-Wolf and the American eagle, employing a New Dada aesthetic. He exhibited at the Quadrennial for the first time in 1965 and took part in the Venice Biennial in 1968 and 1974. Around 1970 he produced many works against the Vietnam war. His "half dollar", an ironic symbol of American imperialism, became a pop art icon. In the 90's he embraced Neo Metaphysics, with citations from italian artists Sironi, Mafai and Scipione.

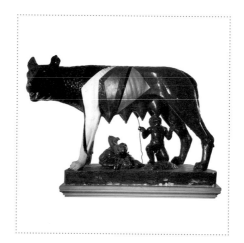

Lupa capitolina parlante
1963
plaster painted sculpture
180 x 145 x 44 cm
Courtesy Collection Carlo Palli, Prato

Mario Ceroli

Was born in 1938 in Castelfrentano. He has always lived in Rome where, at the age of twenty, he
n the prize for young Italian sculpture at the Galleria Nazionale d'Arte Moderna. Working always
h natural materials he has created a poetics linked on the one hand to Arte Povera and on the other
Italian Pop Art. Since 1965 he has exhibited at the gallery La Tartaruga in Rome and since 1968 also
the De'Foscherari in Bologna, the Sperone in Turin and the Thomas in Munich.
1965 he took part in the Rome Quadrennial for the first time and in 1968 in the Venice Biennial,
nes of research from the Informal to primary structures", to which he was invited in 1976, 1982,
34 and 1988.

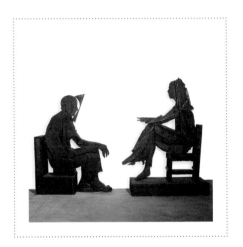

Conversazione
1968
installation
life-size
Courtesy Collection Carlo Palli, Prato

• Pino Pascali

Born in Bari in 1935, his short and brilliant artistic career ended in 1968 when his motorbik
collided with a car. He graduated from the Academy of Fine Arts in Rome (1959) and immediately
made a name for himself as a set designer. His first solo show was at Rome's prestigious gallery La
Tartaruga. In only three years he had attracted the attention of leading Italian critics and avant-
garde gallery owners such as Sargentini, Sperone and Iolas (who presented him in Paris in 1968).
In summer 1968 he had been offered a personal room at the XXXIV Venice Biennial. It was his
consecration: after his death, with the exhibition still open, he was awarded the International Pri
for Sculpture. Sculptor, set designer and performer, Pascali ingeniously and creatively blended
the primary and mythical forms of Mediterranean culture and nature. He made his false sculptures in
fragile, ephemeral materials.

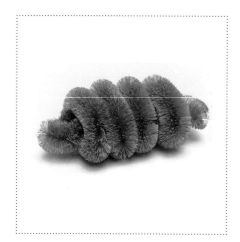

Baco da Setola
1968
plastic and metal
28 x 60 x 38 cm
Courtesy Claudio Poleschi, Lucca

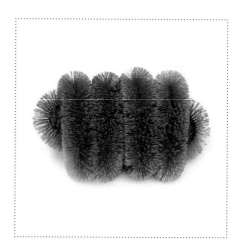

Baco da Setola
1968
plastic and metal
28 x 65 x 47 cm
Courtesy Claudio Poleschi, Lucca

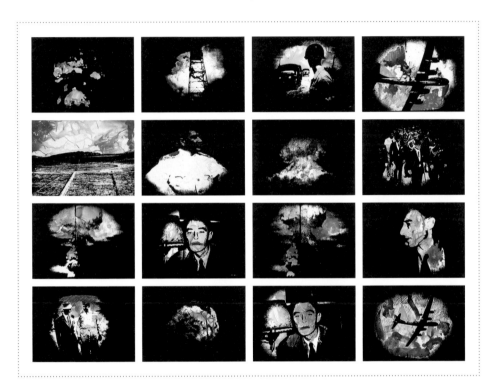

Mario Schifano
Paesaggi TV
1969/70
coloured photographic films
30 x 40 cm
Courtesy Fondazione Marconi, Milano

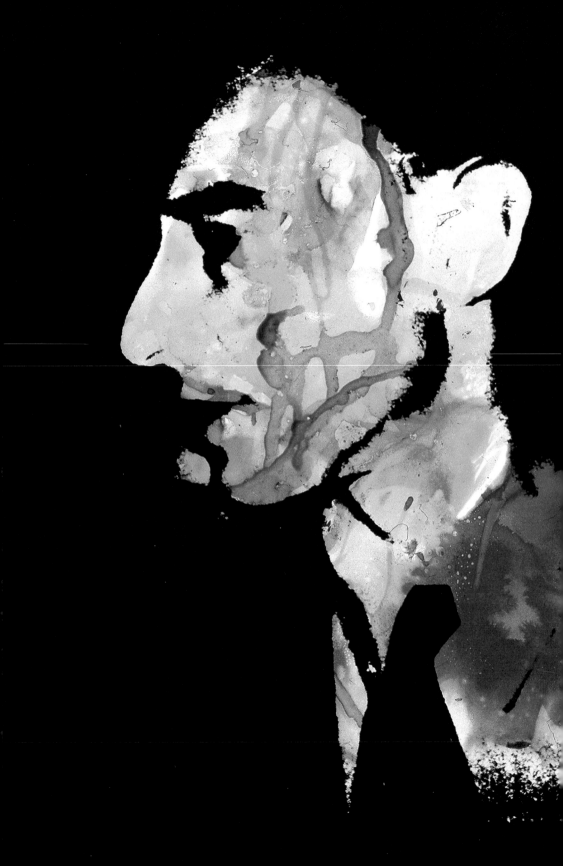

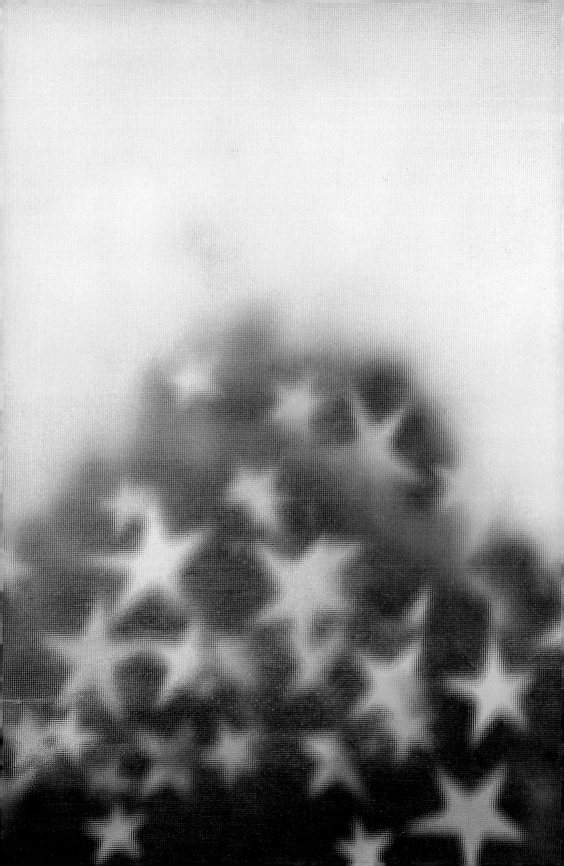

• Mario Schifano

Was born in Homs, Libya in 1934. He came to the fore in 1960 with the exhibition "Cinque pitto
di Roma '60" at the gallery La Salita with Francesco Lo Savio, Giuseppe Uncini, Franco Angeli and
Tano Festa. In 1961 he had his first one man show at the gallery La Tartaruga in which his painting
recalling road signs emerged, influenced by Jasper Johns and Robert Rauschenberg. In 1962 he was
invited to take part in the international exhibition "The New Realists" at the Sidney Janis gallery
New York. He began working in the cinema in 1964. In 1967, at the Studio Marconi in Milan, he present
"Anna Carini vista in agosto dalle farfalle" and in 1968 made the film "Satellite". He often took pa
in the Venice Biennial. He called television his "auxiliary Muse" and in the 70's began painting TV
images with violent colours on an intense black background. He died in a Roman hospital on 26th Janua
1998.

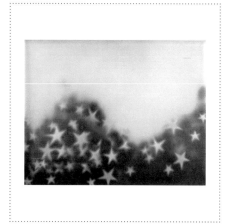

Tuttestelle
1967
enamel on canvas and perpex
100 x 130 cm
Courtesy Fondazione Marconi, Milano

Tuttestelle dedicato a
LP cover
33,5 x 33,5 cm
Private collection, Bologna

Richard Hamilton

Painter and graphic designer Richard Hamilton was born in 1922 in London. After attending ious Fine Arts Academies he began his career with drawings inspired by James Joyce's novel ysses". In 1956 he was introduced to the public at an exhibition that looked wholly towards the ure: "This is Tomorrow". The small collage "Just what is it that makes today's homes so different, appealing?" became a Pop Art icon and was defined as the beginning of Pop Art with Hamilton as its nder. In his art he employs and exploits everyday objects and modern technologies, photographs, vertisements, posters and digital images. There is an important collection of his works in London's e Gallery.

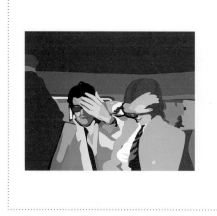

Swinging London
1968
silk-screen process, collage on paper
19 examples
70 x 94,7 cm
Courtesy Fondazione Marconi, Milano

Swinging London
1968
mixed media (photo-engraving,
aqua-fortis, stamping collage and embossing)
70 examples
57,7 x 72,7 cm
Courtesy Fondazione Marconi, Milano

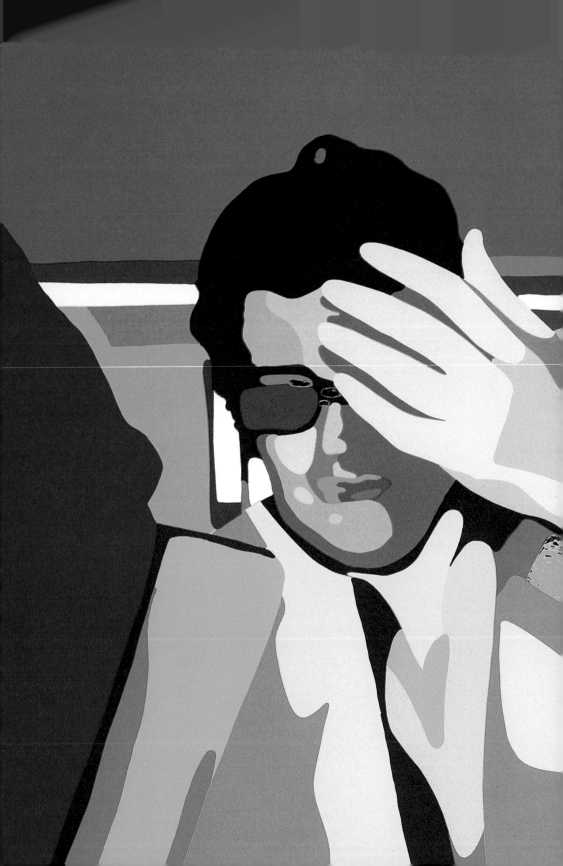

• Marcello Jori

Born in Merano in 1955, he lives and works in Bologna, an artist, performer and musician with a lyrical soul. After graduating from DAMS in 1977, he began his artistic activities and exhibited in national and foreign galleries and museums. With his first photographic works of the mid 70's he intervened on masterpieces of the past, literally interpreting them: art was thus restored to the world. By the same token an abstract painting evoking the sunset was exhibited in the light and colours of a real sunset, "Tramonto sul mare sul mare al tramonto, 1976". After 1979 the painting experience became central to his creative evolution: these were the years of the "Scritture": dizzying fluctuating words suspended between physical space and the artist's mental space. Words that were then caged in the polychrome edifices of the "Teatrini", garish architectures in movement, prelude to the volumes of the subsequent series "Cristalli" and "Gioie", enchanted and kaleidoscopic little geometries.

Moldau on Moldau
1977
series of 24 photographs
Courtesy Fondazione Morra, Napoli

Gianni Ruffi

Born in 1938 in Florence, Gianni Ruffi began exhibiting in 1962 at the Numero gallery in that ...y and in 1966 at La Salita in Rome. In 1986 he took part in the XI Rome Quadrennial. In 2005 he ...ticipated in the exhibition "Pop Art in Italia" at the Galleria Civica in Modena. His works are in ...lic collection such as the GAM of Bologna, the Museum Boymans van Beuningen in Rotterdam and the ...tro per l'arte contemporanea Pecci in Prato.

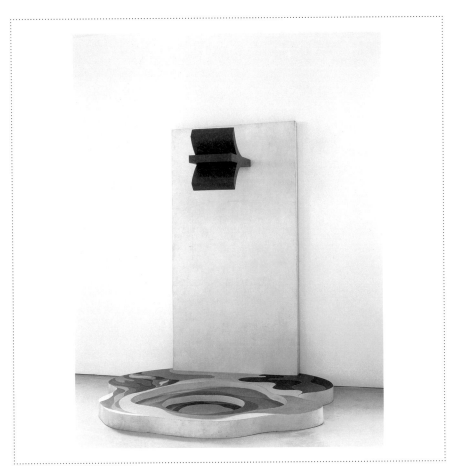

Un bel tuffo
1967
acrylics on wood
240 x 200 x 171 cm
Courtesy Collection Carlo Palli, Prato

· Domenico Gnoli

Was born 3rd May 1933 in Rome, son of Umberto, an art historian, and Annie de Garrou, a ceramicist. From the age of 18 he began exhibiting, first as a graphic artist and designer and later as a painter. In 1954 he lived in Paris where he associated with artists such as Leonor Fini, Ernest Fuchs and Frederich Undertwasser. In 1955 he did the stage sets for "As you like it" at the Old Vic Theatre in London, beginning an international career in theatre and costumes. In 1960 he was known as an illustrator in Chicago and New York where he had a one man show in 1962. In 1966 he returned to Europe, making friends with Balthus and Mario Schifano and accompanying them on a trip to north Tunisia. He had one man shows all over the world, continuing to work as both illustrator and painter. He died at the Columbia Presbyterian Medical Center in New York on 17th April 1970.

Tie
1968
Oil on canvas
141 x 200 cm
Courtesy MUMOK, Museum Moderner Kunst
Stiftung Ludwig Wien

- ## Edo Bertoglio

Born in Lugano in 1951, Edo Bertoglio qualified in film directing and montage at the Conservatoire Libre du Cinéma Français in Paris. A passion for the image led him to choose photography as his main field of action, especially after the effects of seeing Michelangelo Antonioni's film "Blow Up" in his youth. So after a brief spell in London, where he attended the Jone School of English, he went to New York and became part of a new community of artists who in those years were coming together beneath the frontier of 14th Street. It was in this part of Manhattan, worn out by an energy crisis that seemed to decree the failure of the city, that the underground culture succeeded in expressing one of its most fertile and vital periods. An interdisciplinary universe dedicated to experimentation that was capable of short-circuiting music, art, poetry, cinema and photography. Some of the people involved would shortly become actual points of reference, talents like Jean-Michel Basquiat and Keith Haring, singers like Madonna and Debbie Harry, bands like the Ramones, the Lounge Lizards and the Talking Heads, cineastes like Jim Jarmush, actors like Steve Bushemi and Vincent Gallo. In brief, the crossroads for a new generation of artists who met at theme parties which in turn gave rise to fashion shows, performances, the showing of shorts and Super-8 films. And it was precisely by immersing himself in the creative fever of the downtown scene that Edo Bertoglio grew to professional maturity, working as a photographer for various American and international fashion and art magazines including Rolling Stone, Art Forum, GQ, Vanity, Spin and Vogue. This was the period when the Ticino photographer managed to meet Andy Warhol, the authentic catalysing centre of every New York trend. "All of a sudden" says Bertoglio "I found him right in front of me with his blond wig, his ironic stamped-on smile, his laconic phrases. His curiosity was aroused and Warhol leafed through my photographs that were bound in a fine, regulation-type book. He asked where I was from, smiled, and told me he had been to Lugano himself as the guest of Baron von Thyssen and found it fabulous. I had to tell him I'd left the town because it was too boring. His reply was lapidary and paradoxical: it's because it's boring that I'd like to live there." The talk finished there, but collaboration with Andy Warhol's historic magazine Interview would continue for several years, refining Bertoglio's propensity towards portrait photography. What captured his attention above all were the faces of that odd gallery of characters that passed by every day downtown. Eccentric faces selected on the basis of cinematographic criteria, almost as if they already possessed "self-film direction" in the way they presented themselves. The result was Bertoglio's early catalogues of faces, photographed at first on the street or in public places and later, always with greater conscientiousness, in his studio. With overexposure of light the trait is retained while matter and details are removed, almost making them figurines. Or better, Cult Figurines, as his writer friend Glenn O' Brien defines them. The breadth of all these experiences was to result in the film "Downtown 81", completed only in 1999 after a long series of adversities and presented at Cannes in the Quinzaine des Réalisateurs. An urban fable whose protagonist is Jean-Michel Basquiat, here raised to the prototype of that community of New York artists who in the space of very few years left their mark on international culture. An influence so powerful that almost thirty years afterwards Edo Bertoglio wanted to go back to those places and film some of the "survivors" of that adventure. In fact in the 2006 documentary film "Face Addict" this Ticino photographer's biographical story is at once individual and collective, re-exploring the success of a shared scene, but also the shadow of a problem-ridden descent, often in solitude amidst bereavements, AIDS and drug dependence, right down to the second chance of rebirth for those who managed to rebuild a new life.

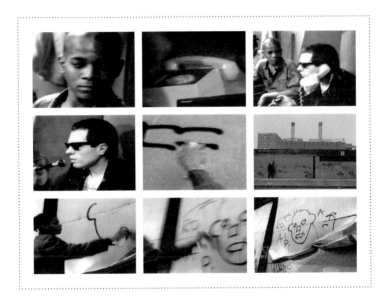

Jean-Michel Basquiat in Downtown 81
1981
video
1,15 Not Rated - Zeitgeist Films Ltd.

Raymond Pettibon

Was born in Tucson, Arizona in 1957. A cult figure in underground music, he began his painting and drawing activities on the Los Angeles punk rock scene. Recurrent in his work are many of the social and political themes of the 60's as well as other pop culture themes. He has had numerous retrospectives in various museums including the Philadelphia Museum of Art, the Santa Monica Museum of Art and the Chicago Museum of Contemporary Art. In 2002 an exhibition of his drawings was organis by the Barcelona Museum of Contemporary art, a show which then proceeded to Tokyo and Holland. Pettibon took part in Documenta XI in Kassel.

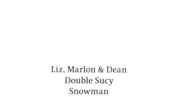

Liz, Marlon & Dean
Double Sucy
Snowman
On the Bed
DVD
Raymond Rayman Medien.Kunst Tirol Los Angeles
Innsbruck 2002

Snowman
DVD
Lyrics Raymond Pettibon
Musik: Hans Weigand, Stefan Binder
Raymond Rayman Medien.Kunst Tirol Los Angeles
Innsbruck 2002

GADDA

VIDA

Pop goes Art - Art goes Pop | *The psychedelic posters of San Francisco*

Uwe Husslein | Two of the Beatles' album covers. On the first, *Please Please Me* (1963), the group are still dressed in their classic matching suits: four guys with a somewhat awkward air smiling into the camera from the balcony of EMI headquarters in London. In those days photo-shooting was done almost fortuitously during a visit to the record company. The images and typefaces are simple and conform with the traditional advertising graphics principles of the day.

In contrast, "Sgt. Pepper's Lonely Hearts Club Band" appears on the cover of the 1967 LP of the same name wearing fantastical multicoloured uniforms that recall the world of the circus. The design – the work of English pop artists Peter Blake and Jann Haworth – presents the Beatles in front of a collage of full-length portraits of historical and contemporary figures ranging from Edgar Allan Poe, Karl Marx, Mae West, Aleister Crowley, Marlene Dietrich, Wallace Berman, William S. Burroughs and Marlon Brando to Bob Dylan and the Rolling Stones. The aesthetic conception of this cover alludes to the cultural and political influences behind the Beatles'

music which, since it was a part of historical processes, was also subject to change. Thus the insertion of waxwork (!) statues of the group in their classic matching suits, and the word "Beatles" set at the bottom of the collage in a funereal flower arrangement, may be interpreted as an ironic allusion to the group's historicity. The idea behind this highly elaborate artwork introduced new criteria into album cover design. *Sgt. Pepper* was the first record in the history of pop with a folding cover and all the song lyrics reproduced on the back.

The above examples clearly show not only the Beatles' process of aesthetic-artistic transformation but also reveal in an exemplary way a change in the paradigms of pop music. This change manifested itself radically in the climate of 1967, rich in cultural ferments. The "old" Beatles are dead and Sgt. Pepper's Lonely Hearts Club Band announces the advent of a new age. The musicians play the role (to recall another important title of that year) of *Piper At The Gates Of Dawn* (Pink Floyd's first album). The growing awareness of pop musicians and the commercial value of their

music were now increasingly noted by representatives of other, so called "serious" cultural fields such as cinema, literature and the figurative arts. The content of pop music still caused it to be seen as a non-art youth form, but as a method for addressing a vast public and exerting real aesthetic-social influence it seemed nonetheless superior to other cultural manifestations that addressed a small elite of experts. With its heavy accentuation on mass culture the Pop Art movement, which sprang up around 1960, led to the modern mass phenomenon of pop music being taken into consideration in the art field. Andy Warhol's meeting with the Velvet Underground in New York turned out to be particularly rich in developments. Their collaboration resulted in pop object-books such as the *Aspen-Box* (1966) and the *Index Book* (1967) with the Velvets' records attached, in the multimedia show *Exploding Plastic* Inevitable and the celebrated cover with a banana that could be peeled, designed by Warhol for the group's first LP (1967). In London it was chiefly the gallery owner Robert Fraser who put artists like Peter Blake and Richard Hamilton in touch with pop groups for record sleeve design. The Beatles had begun a process which was followed by various collaborations between pop music and other arts that contributed to enrichment and differentiation of the musical and literary means and the aesthetic-visual aspects of Pop. Although the Beatles, in virtue of their commercial success alone, were an important catalyst in the increasing visualisation of pop music, the synthesis familiar to us today of sound, visuals and design did not come into being in Liverpool, London or New York. The epicentre of this new movement was actually on the west coast of America. Around 1965 the Haight Ashbury district of San Francisco was the centre and birthplace of the hippie movement. The writer Ken Kesey stands in direct relationship with the history of the origins of this new youth subculture which produced new forms of aesthetic-artistic expression such as dance rock concerts, acid rock, light shows, psychedelic posters etc. Right from his first book *One Flew Over The Cuckoo's Nest* (1962) Kesey had gained fame in the literary world as a young novelist

to bring about a change in the participants' sensorial, spatial and temporal perceptions. During the acid tests the Pranksters painted the spectators with fluorescent colours so that their bodies and faces shone in the stroboscopic light like alien and fantastical apparitions. As house band for these events Kesey engaged the Grateful Dead, then completely unknown. Under the influence of these happenings they were transformed from a traditional rhythm'n'blues outfit into the prototype of the psychedelic acid rock band.

full of promise. After taking part in a series of medical experiments in which he was given psychedelic substances, the decision grew in him to turn against the literary establishment and carry out wholly new artistic experiments.

"Rather than write, I will ride buses, study the inside of jails, and see what goes on." Kesey brought together a group who shared his ideas: they called themselves The Merry Pranksters. Under the mistrustful eyes of the authorities they led a nomadic life in an old school bus that they had kitted out with all kinds of electronic apparatus and painted with bizarre ornamental motifs in fluorescent colours. After having driven the bus around the States, at the end of 1965 the Merry Pranksters starting organising a series of multimedia happenings in the Bay Area, under the motto Can You Pass The Acid Test? During these happenings – drug use was legal in California until October 1966 – LSD was freely distributed. Kesey was one of the first to recognise that through the massive use of coloured lights, stroboscopes, slide and film projections plus collages of music and sounds, it was possible

Side by side with the mixing of various art forms, it was the sensation of freedom that offered the musicians new artistic prospects and favoured their going beyond the traditional aspects of pop music with its conventional three chord trick songs and well groomed performers moving to a studied choreography. To announce the acid tests Norman Hartweg created a poster whose montage technique and variable typefaces – like those used by the futurists and dadaists – differed strikingly from the pop posters of the day where the letterpress technique generally offered the beholder only simple, highly legible information about place, date and performers. Whereas Hartweg, by free association, put together citations from texts and images of different cultural epochs in order to highlight the multiple aspects of the happenings. The acid tests, inasmuch as they were multimedia events, were a model for the innumerable dance rock concerts of the late 60's featuring the bands that had grown out of the psychedelic underground culture of the Bay Area: Jefferson Airplane, Grateful Dead, Steve Miller Band, Quicksilver Messenger

copies but it soon rose to 5000.

Now, with the offset process, more posters were printed than were needed to advertise the events. They were sold as souvenirs in galleries, record stores, headshops and through special distribution agencies who sent them to customers worldwide.

The new poster style drew on the figurative arts (Art Nouveau, Max Ernst, Van Gogh, Josef Albers etc.) and on photography (Edward S. Curtis, Edward Steichen and others). Other references were to the dream factory of Hollywood and elements of American mass culture, as well as to Indian symbols and the myth of the wild west.

A deep influence was also exerted by the atmosphere of dance rock concerts. The hallucinatory effects of these multimedia shows are reflected in the accentuation of bright colour contrasts and fluid ornamental forms, as well as in the use of a ciphered iconic language. These graphic designers did not come from commercial advertising agencies: they were part of the hippie scene, from which they drew much inspiration.

The first poster designer to have considerable influence on development of the psychedelic style was Wes Wilson. In the mid 60's, having dropped out of his Philosophy course, he worked as an apprentice typographer with the company Contact Printing in San Francisco. Here he was given his first assignments, the graphic design for Chet Helms' "open theatre shows" and for Kesey's Trips Festival (January 1966). His drawings had such great success that both Chet Helms and Bill Graham approached him to do posters. Over and above the first one for Graham, between February 1966 and May 1967 Wilson created

Service, Moby Grape, Santana, Big Brother & The Holding Company with singer Janis Joplin now played regularly in clubs like Bill Graham's Fillmore and the Avalon Ballroom, run by Chet Helms' Family Dog group. For these events a special kind of poster was designed which cast radical doubts on the traditional principles of advertising graphics (e.g. legibility) and which in general contributed to renewal in the graphic arts. From February 1966 to November 1968 at least 147 posters in numerical sequence were created for the Avalon Ballroom, and from February 1966 to summer 1971 at least 287 drawings for the Fillmore. In September 1967 the American magazine *Life* did a cover story on nascent poster production in San Francisco, making the new psychedelic style of advertising posters very popular, a style that had been deeply influenced by graphic designers like Wes Wilson, Mouse Studio, Victor Moscoso and Rick Griffin. Their works, were collector's items right from the start. The posters had hardly been put up when they were carefully removed, ending up on the walls of rooms in Haight Ashbury. At first they had a print run of 300-500

all the posters for the Fillmore. At the same time, for Chet Helms' Avalon Ballroom, he did 11 of the first 12 posters for Family Dog. The clearly different features of the posters reveal the difference between the intentions of the two impresarios Graham and Helms. While Wilson's drawings for Family Dog transmit a direct message through determined images, his works for the Fillmore stand out above all for the writing. In November 1965 Wilson had seen an exhibition of Art Nouveau at Berkeley and he adapted the typefaces elaborated by Alfred Rolle in Vienna between the late 19th and early 20th century. The ornamental forms that cover the entire surface of Wilson's posters also bring to mind the work of Viennese graphic design studios and the Japanism influenced paintings of Gustav Klimt.

Wes Wilson's successors at Family Dog were Alton Kelley and Stanley "Mouse" Miller who, from June 1966, continued poster production under the name "Mouse Studio". They produced an overall number of 29 posters for Family Dog as well as several others which they signed individually. For Graham's Fillmore they worked together only in winter 1967/68.

Kelley, having dropped out of art school, became an apprentice mechanic. Miller, son of a film animator, came from Detroit where he had attended design school. Starting in the late 50's he earned his living painting motifs from comics on cars and T-shirts. "Mouse Studio" production is distinguished by an original use of texts and images from American mass culture. Mouse was in charge of typography and layout while Kelley handled photography and collage. The two graphic designers became famous chiefly for numerous works done for the Grateful Dead.

Victor Moscoso was one of the few poster and comics artists who could boast an academic artistic training. After attending Cooper Union School in New York he studied at Yale University under Josef Albers, a former Bauhaus teacher, and in October 1957 he moved to San Francisco to complete his studies at the California School of Fine Arts.

For Family Dog Moscoso created 22 posters between October 1966 and February

1968 but only two – for concerts at the Fillmore Auditorium in 1968 – bear his signature Moscoso's work reveals multiple relationships with the kinetic painting of 1960's Op Art. Like no other San Francisco artist he tried to activate and manipulate the observer's perception through considered use of luminous contrasting colours. In their scintillating and phosphorescent effect his works reflect the visual overexcitement and the overturning of perceptual constants which, at the dance rock concerts, were elicited by massive use of optic-kinetic apparatus. The culminating point of his production is the series of posters Neon Rose (1966/67). Here, through application of chromatic laws and knowledge of the psychology of perception, Moscoso achieved an intensely luminous plastic-spatial kinetic effect.

Rick Griffin had already made his name in the field of comics, creating the popular character "Murphy" for the Southern California Surfer-Magazine, when he arrived in San Francisco at the end of 1966 with a jug band, The Jook Savages. He had studied at the Art School of Los Angeles. With his

first posters for the Psychedelic Shop and the "Human Be-In", between 1966 and 1967, he attracted the attention of Chet Helms who gave him other commissions for Family Dog.

From March to July 1967 Griffin did all the posters for Family Dog, alternating regularly with Victor Moscoso. In the predilection for 19ᵗʰ century Indian and trapper motifs, these works reflect essential elements of the hippie philosophy. It was only towards the end of 1967 that Griffin developed a new comics style that came to the fore above all in his posters for Bill Graham's Fillmore. These intensely coloured posters feature hieroglyphics and are full of flora and fauna motifs from the psychedelic world. This production was carried on into his work for Robert Crumb's Zap magazine. These works, similar to Moscoso's, are centred more on the visual aspect than on text. Griffin's most famous record cover is certainly the one he did in 1969 for the Grateful Dead's "Aoxomoxoa". The design was originally taken from a poster for one of the band's concerts. The propensity towards religious psychedelia, already hinted at in this cover,

Stimulated by an article about Wes Wilson's posters, Lee Conklin moved from New York to San Francisco during the "summer of love". He showed his first works – inspired by Heinrich Kley and Saul Steinberg's pen and ink drawings – to Bill Graham and was engaged, between 1968 and 1969, to do posters for 33 shows at the Fillmore. Conklin's posters, with their sketched impressionistic line, are distinct from his predecessor's well delineated outlines. As for content, in these posters the artist doesn't tackle questions of transcendental consciousness or calculated perceptual manipulation. Rather, Conklin elaborates worlds of his own, full of bizarre images. His posters resemble rebuses which elude univocal perception and interpretation. Strange figures move in anthropomorphic landscapes, monstrous, hybrid and fabulous beings that may be interpreted as imaginative products of a psychedelic state of consciousness, although they certainly have models in the world of the figurative arts. In a poster for the Jeff Beck Group, for example, Conklin employs an ornamental motif from the Renaissance and early Baroque: fantastical plant forms and uneasy figures of people and animals growing from the thin offshoots of a tendril.

Among Lee Conklin's successors who worked for Bill Graham until the Fillmore West was closed in July 1971, David Singer has a special position.

When he arrived in San Francisco in 1964 he already had contacts in the graphic arts sector. In spring 1969 he showed Bill Graham some of his works and was hired with a two year contract. From mid June

found its fulfilment in the comic "Man from Utopia" (1972): this work is characterised by themes like illumination and death as redemption, as well as numerous biblical allusions.

When Wes Wilson resigned from his job with Bill Graham in May 1967, poster production was assigned to Bonnie MacLean, the only outstanding woman among the San Francisco poster artists. Though she had no professional artistic training she created almost all the Fillmore posters until early 1968. Her works represent an eclectic continuation of Wilson's style and evince, even more than his works do, the influence of fin de siècle symbolic art. At the end of 1969 MacLean created for the first time posters in black and white in which, with fragments of photographs, she achieved autonomous poetic images.

1969 until July 1971 Singer created an overall 66 posters for the Fillmore West and Winterland. His works feature a clear, geometric layout and a cool iconic language with classical tendencies. His photo collages stand out for their power of visual imagination. They emanate a tranquillising almost surrealistic atmosphere. From mid 1970 a stylistic change can be noticed, traceable above all to the influence of Wilfried Sätty, an artist from Bremen (1939-1982). At first Singer used only photographs and reproductions taken from contemporary magazines and books, but in a subsequent phase he made his collages with illustrations from 19th century fairytale books and mass market romances. Characteristic of Sätty's works is an alogical and poetic language which also finds expression in the posters created in tandem with Singer.

Though it came into being solely for advertising purposes, the psychedelic poster had been transformed, in the eyes of the Californian youth movement, into an important means of communication in which social and cultural opposition to the American way of life found its own form of artistic expression. Independently of the advertising and commercial nature of the posters, they were adopted by hippies as an artistic expression of their taste in life, governed by music, movement, light, colour and poetry. Notwithstanding the new directions taken by the San Francisco poster designers on the thematic and formal plane, official art history had long ignored their innovative contribution to the development of 1960's graphic art. It is only with the current itinerant exhibition "Summer of Love" (Liverpool - Frankfurt - Vienna - New York 2005/07) that these posters have been presented as a special sector of 1960's psychedelic art. The heavy accentuation, obvious to us today, on visual aspects in the presentation of pop music – from video clips to VJs – has its origins in the San Francisco dance rock scene and the psychedelic poster.

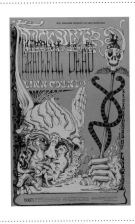

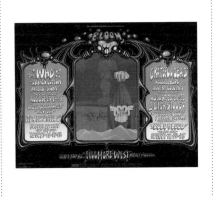

Lee Conklin
Artist: Quicksilver, Grateful Dead, Linn Country
Notes: 2nd print
Producer & no: Bill Graham presents BG 144
Date: 7. - 10. 11. 1968
Poster
Courtesy Uwe Husslein

Kelley & Rick Griffin
Artist: The Who, James Cotton, Magic Sam,
Creedence Clearwater Revival,
It's A Beautiful Day, Albert Collins, Grateful Dead,
Kaleidoscope, Quicksilver, Spooky Tooth,
Cold Blood
Producer & no: Bill Graham Presents BG 133
Date: 13. - 15. 8. 1968
Poster
Courtesy Uwe Husslein

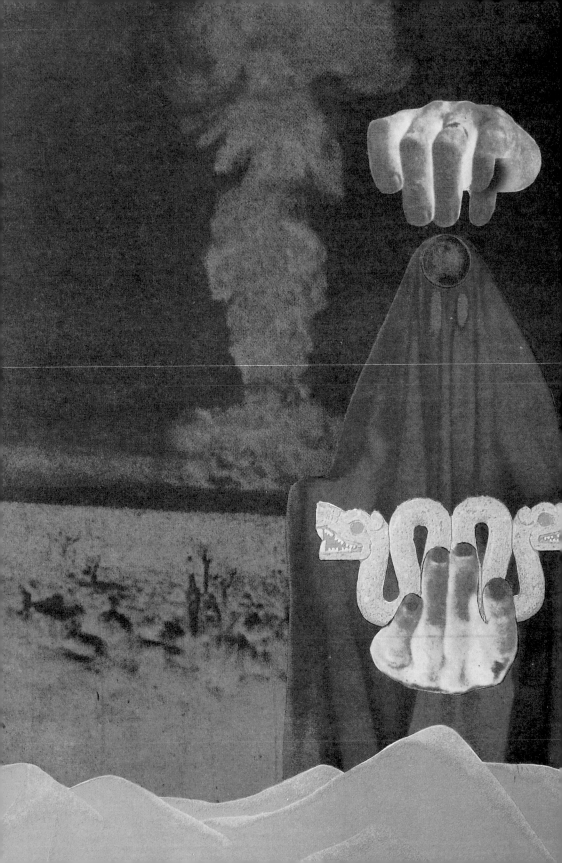

Bob Fried
Artist: Buffalo Springfield, Eighth Penny Matters
Producer & no: Family Dog FD-D 5
Date: 6. - 7. 10. 1967
Poster
Courtesy Uwe Husslein

Randy Tuten, Jim Marshall *(Photo)*
Artist: Taj Mahal, Buddy Guy, Spooky Tooth
Producer & no: Bill Graham presents BG192
Date: 18. - 21. 09. 1969
Poster
Courtesy Uwe Husslein

Lee Conklin
Artist: Procol Harum, Santana, Salloom Sinclair
Producer & no: Bill Graham presents BG 143
Date: 31. 10. - 2. 11. 1968
Poster
Courtesy Uwe Husslein

Bonnie MacLean
Artist: Quicksilver Messenger Service, Grass Roots,
Mad River
Notes: 1st print, PH
Producer & no: Bill Graham presents BG 87
Date: 5. - 7. 10. 1967
Poster
Courtesy Uwe Husslein

Kelley
Artist: Vanilla Fudge, Charles Lloyd Quartet
Producer & no: Family Dog FD 85
Date: 29. 9. - 1. 10. 1967
Poster
Courtesy Uwe Husslein

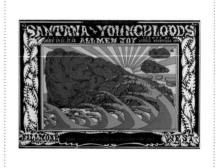

Lee Conklin
Artist: Santana, Youngbloods, Allmen Joy
Producer & no: Bill Graham presents BG 173
Date: 15. - 18. 5. 1969
Poster
Courtesy Uwe Husslein

Victor Moscoso
Artist: Poster show of work by various artists
Producer & no: Neon Rose 21 (B-2),
Nieman Marcus Exhibtion Hall, Dallas
Date: 1967
Poster
Courtesy Uwe Husslein

Rick Griffin & Victor Moscoso
Artist: Chuck Berry, Sons of Champlin
Producer & no: Family Dog FD-D 12
Date: 17. - 18. 11. 1967
Poster
Courtesy Uwe Husslein

Rick Griffin
Artist: Quicksilver, Kaleidoscope, Charley
Musselwhite
Producer & no: Family Dog FD 101
Date: 12. - 14. 1. 1968
Poster
Courtesy Uwe Husslein

Victor Moscoso
Artist: Steve Miller B.B., Siegal Schwall Band
Notes: PH
Producer & no: Family Dog FD 70
Date: 6. - 9. 7. 1967
Poster
Courtesy Uwe Husslein

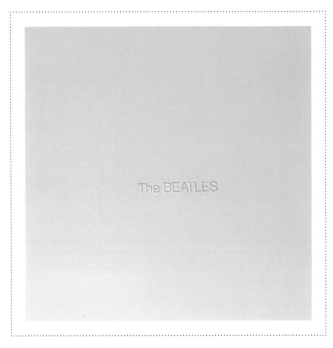

Richard Hamilton
The White Album
The Beatles
1968
Apple Records, London
Courtesy Klaus Knop

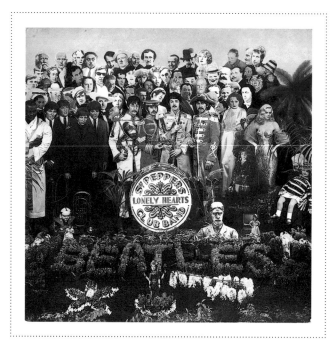

Peter Blake & Jann Haworth
The Beatles. Sgt. Pepper's Lonely Hearts Club Band
1967
Odeon/EMI
Private collection, Bologna

Franco Vaccari

Was born in Modena in 1936. After graduating in Physics he devoted himself to artistic and
otographic research. In 1978 he published "Duchamp e l'occultamento del lavoro" (Duchamp and
ncealment of the Work) and in 1979 "La fotografia e l'inconscio tecnologico" (Photography and the
chnical Unconscious). He had a personal room at the Venice Biennial in 1972, 1980, 1993 and 1995.
 1984 he exhibited in Vienna at the Museum Moderner Kunst. He has also taken part in several Trigon
ents in Graz and in the main collectives of Italian art worldwide. In 1969 he began the series, now
mbering more than 30, of "Exhibitions in real time" in which he carries our interventions, actions,
stallations and performances dedicated to contemporary cultural themes.

Pop Festival Isle of Wight
1970
photographic print
30 x 40 cm
Courtesy of the artist, Modena

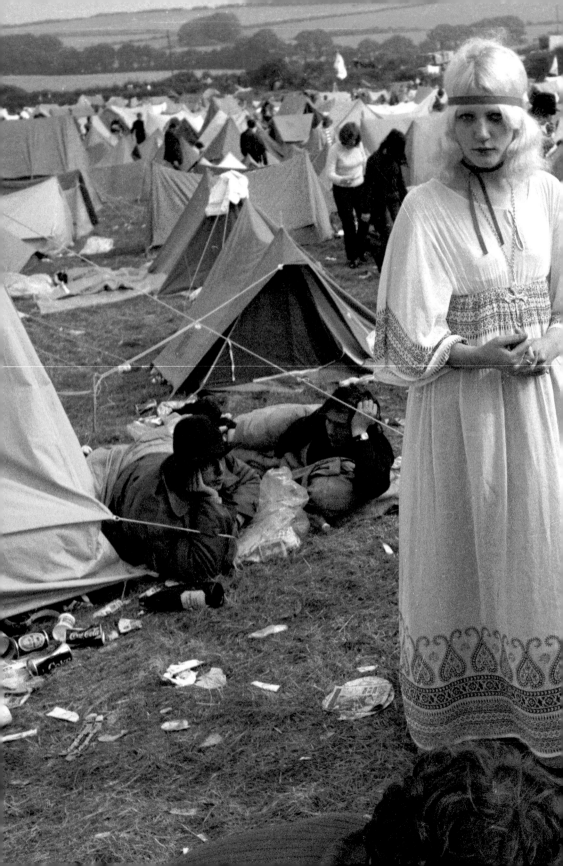

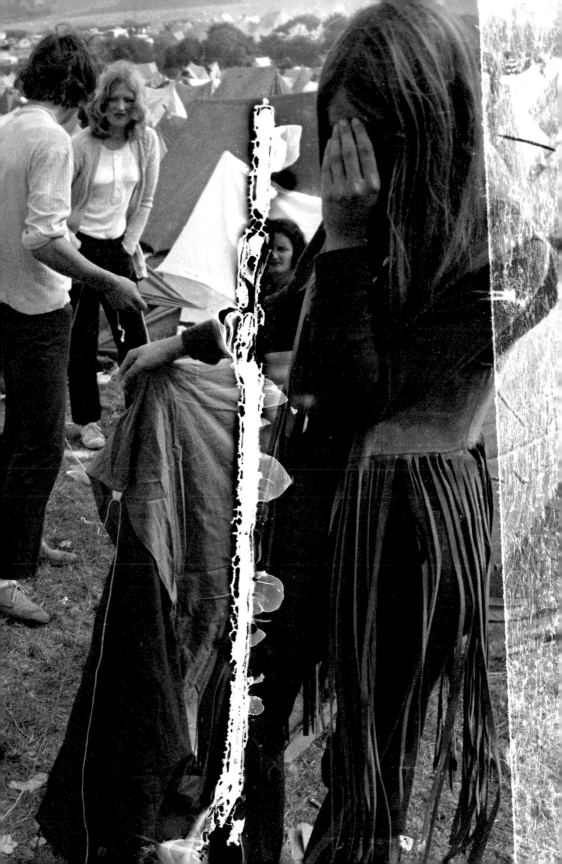

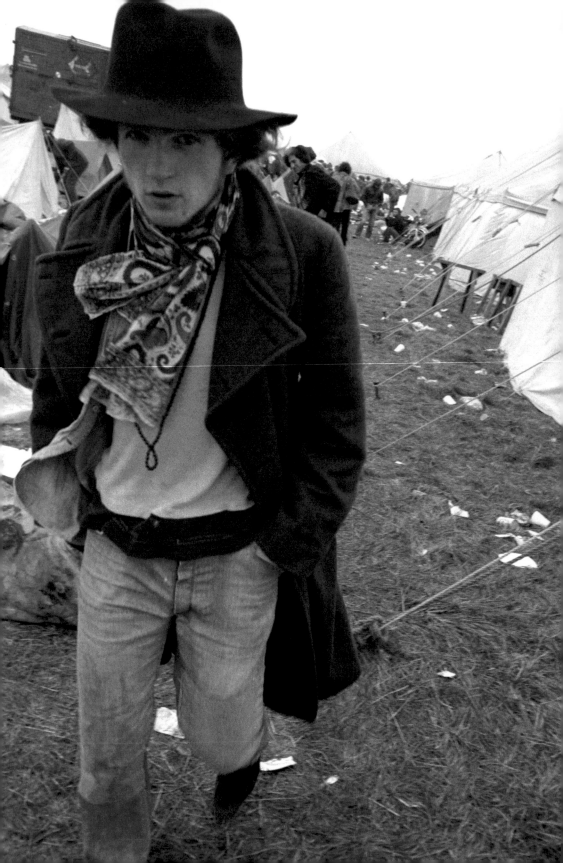

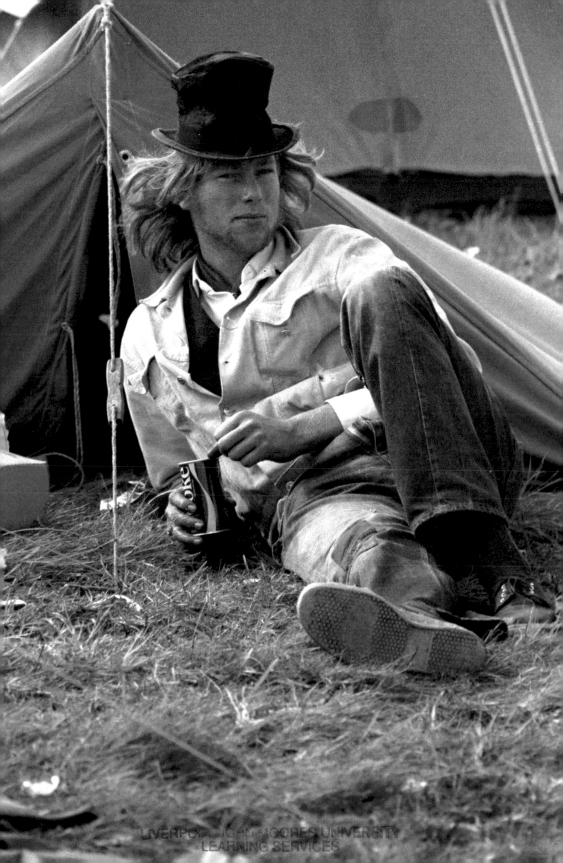

I'll go crazy
I New Dada
1966
Bluebell Records
Private collection, Bologna

Pictures at an exhibition
Mussorgsky
Emerson Lake & Palmer
1972
Greg Lake for E.G. Records
Private collection, Bologna

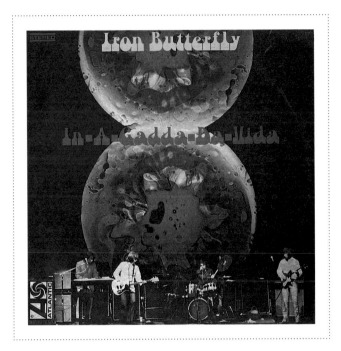

Iron Butterfly
In A Gadda Da Vida
1968
Private collection, Bologna

- Bruno Benuzzi

Born 1951 in Argentiera (Sassari), he spent his childhood between Oristano, Olbia and chiefl Alghero. From '62?? he studied at the DAMS of Bologna and gained his diploma from the local Fine Art Academy where he now teaches Painting. Since 1977 he has exhibited in Italian and foreign galleries and in 1982 was a member of the group of New Italian Painters who called themselves the Nuovi Nuovi. His painting is characterised by a special technique which, by mixing flour with the colours, gives the work a velvety, slightly relief effect.

Dita Rock
1988
mixed technics on wood, flour and enamel
Ø 60 cm
Courtesy of the artist

Guy Harloff

Was born in Paris on 4th June 1933 to a Dutch father of Russian origin and a mother of Italian [ori]gin. From the late 50's to the early 60's he lived and worked at the Beat Hotel in Paris, a meeting [plac]e for beat generation members passing through. From 1965 to 1968 he lived in Milan where he worked [wit]h Arturo Schwartz and Carlo Cardazzo. In 1973 in Chioggia he launched a 25 tonne boat called "Le [P]enir", living aboard her for several years before moving to the Chelsea Hotel in New York. In [198]5 he came back to Italy where he died on 6th January 1991. Harloff also made two films: "Petite [c]entaire" and "About Life". Writers such as William Burroughs wrote about him and Patrick Waldberg, [a] historian of surrealism, dedicated a monograph to him. In 1974 Harald Szeemann invited him to [Doc]umenta in Kassel.

Elements - WS46-61
1961
mixed technics on cardboard
20 x 27 cm
Courtesy Galleria Sorrenti, Novara

My own kind swastika Ms 65-66
1965 - 1966
mixed technics on cardboard
29 x 26 cm
Courtesy Galleria Sorrenti, Novara

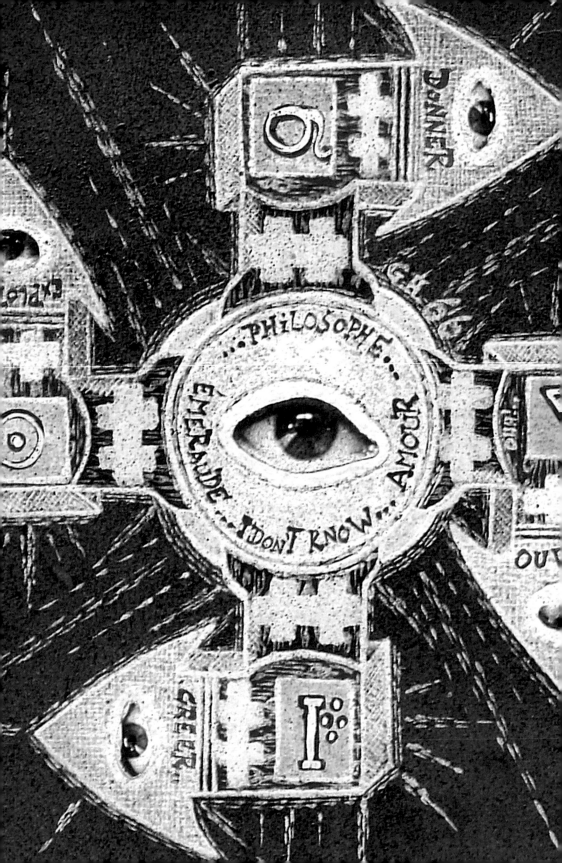

WHERE

THE

STREETS

HAVE

NAME

- Jean-Michel Basquiat

Born in 1960 in Brooklyn, New York, he died of an overdose in the same city in 1988. His father came from Port-au-Prince, Haiti, and his mother was born in Brooklyn to Puerto Rican parents. His relationship with his father, who worked as a bookkeeper, was constantly difficult and as a boy he often ran away from home. After attending various state schools he decided to enrol at the City-As-School, a lay school for gifted children with problems of integration. In 1977 he invented the logo Samo with which he signed his graffiti in downtown Manhattan. In the same year the "Soho News" print photographs of his graffiti, contributing to his fame. Basquiat rapidly became a star in the art wo. between Zurich and New York, Tokyo and Los Angeles. He attracted the interest of great art dealers such as Mary Boone, Larry Gagosian and Bruno Bischofberger. His works swiftly commanded dizzying prices. "At seventeen I was already convinced I'd become famous. I thought about all my myths: Charl Parker, Jimi Hendrix… I had a romantic curiosity about how people had made it." Describing himself, Jean-Michel Basquiat stated that painting was his work and always had been. "I've always painted, long before painting became fashionable." His works are a rosary of images, set next to each other, which recur and sometimes are superimposed to form a broken-up story, sometimes tragic and often ironic. But it isn't important to find the complete meaning and the narrative thread: Basquiat's ico get stamped on the eyes like a potent lay reliquary, dense with mixed outlines and hurried writing consisting of lots of words but also numbers and the names of people, towns, states, dates of birth and death and parts of the body. There are also sign-symbols borrowed from Hobos, the American tramp who used them to mark the walls of houses in order to warn other tramps of any dangers. Basquiat's works appear to us as actual maps in which windows of rage and desire open up, incessant notes on life coloured with "wild child" impulsiveness. Many works consist only of lists of names and words, defined as " facts".

In 1979 the words "Samo is dead" appeared on walls in Soho. In truth Basquiat did not forget Samo quite so soon and numerous 1981 paintings bear the Samo trademark, with a smaller s accompanied by a crown. At the beginning of the 80's he started a band and for all his life was passionate about pop, beat and rap music In the same years he got to know Keith Haring and Kenny Scharf. In 1980 he had his first collective exhibition at the "Times Square Show" with Jenny Holzer, Kenny Scharf and Kiki Smit In 1981 he was the main character in Edo Bertoglio's film – which came out only in 2000 – entitled "Downtown 1981". Diego Cortez, a co-founder of the Mudd Club, put him in touch with Swiss gallery own Bruno Bischofberger who in turn introduced him to Andy Warhol and to the Italian Emilio Mazzoli who put on an exhibition of his work in Modena in 1981, stilled signed "Samo". In the same year he had hi first solo exhibition in the States at Annina Nosei's gallery. After breaking with Nosei he exhibite in Zurich and at the Fun Gallery, enjoying great successes. In 1983 he got to know Warhol better and moved into a studio rented from the latter in Great Jones Street where he would work right up to his death. Collaboration with Warhol aroused polemics and negative comments. Basquiat felt offended by being considered a sort of black mascot in the hands of the most famous white artist and businessman On Warhol's death in 1987 he fell into an inconsolable dejection, even though he had already decided to stop working with him. Death, with its classic symbology from skulls to skeletons, is found in ma of his works as the destiny of heroes, martyrs, of those who suffer an unjust and violent fate which they intend to redeem.

Samo I
1981
white charchoal on cardboard
100 x 70 cm
Courtesy Galerie Thaddaeus Ropac Salzburg, Paris

Samo II
1981
white charchoal on cardboard
100 x 70 cm
Courtesy Galerie Thaddaeus Ropac Salzburg, Paris

1 | How much is it important the music for the Street Culture?

I believe music is very important to all cultures, especially the creative cultures, so there is really no reason why those people involved in the Street Culture community should be any different. If one looks at underground creative movements throughout history, especially modern history, then music has always played a major part. The Beat Generation had Jazz, The Hippies had psychedelic music... every generation has to find its voice through music.

2 | According to your opinion when did this phenomenon start?

In the early 1980s, during the Ronald Reagan era, when Street Culture first developed in America, a whole new generation of musicians were coming into existence at the same time. On the West Coast, particularly in California, the failure of the American dream coupled with a gross display of materialism on the part of the media forced teenagers underground, alienated from what they thought to be their dead-end suburban existence. Based loosely on the punk movement from England, these California youths started "hardcore" bands in their garages and a new music was born. This music blended perfectly with the new outsider sport of skateboarding and by 1984 a true subculture had formed around these two communities, spawning bands like Black Flag, The Germs, Suicidal Tendencies and Dead Kennedys. Meanwhile on the East Coast in places like New York and Philadelphia, using not much more than two turntables, a mixer and a microphone, another new kind of music, soon to called Hip Hop was being forged in ghetto basements. Groups like Run DMC and Public Enemy would emerge early on as its leading voices. The hybrid Hip Hop, fused with the new popping and blocking style of breakdancing merged with the raw concrete and steel canvas of the New York Subways where the youth had started to howl in spray paint, giving birth to Graffiti pioneers like Futura, Lee and Dondi. It was an exciting time. Punk and Hip Hop became the voices of a generation and I believe these two forms of music have been directly

or indirectly responsible for all musical developments since to date.

3 | Why a lot of artists in Europe and in USA play music with a personal band?

I personally believe that the 20th Century broke down many of the restrictions that existed in the arts before that time. Before that the painters stuck with the painters, the poets stuck with the poets and the musicians stuck with the musicians. As early as the 1920s artists were already experimenting with different mediums and collaborating with each other. I believe that the current phenomenon of artists playing in bands is a direct result of this lineage. We no longer live in a society where the notion of an artist needs to be defined in such simple terms. I believe Andy Warhol had a lot to do with this change. Warhol made it OK the same artist to be a painter, photographer, musician, filmmaker, writer, whatever touched him/her. I also believe that music is particularly attractive to the visual artist because of its inherent collaborative qualities. Sometimes being an artist can be very lonely work in the

studio. Making music gives one a chance to work with other people and exchange ideas together.

4 | In the contemporary art it's difficult that artists live together or make a group, in the music it's normal. Is there a difference?

I'm not sure I agree with the point that it is difficult for contemporary artists to live together. I just don't think that this is what is taught. From very young ages, artists are taught that they must toil away in their studios in order to create their work but I don't necessarily believe that is correct. I think that is an outdated romantic concept that has been sold to us by art history. I prefer to believe that working alone or with a group is a personal choice for an artist. We must admit, however, that there are indeed some fundamental differences between creating a painting lets say and a composition. The amount of instruments alone is an example. To create a painting one only needs a paintbrush, a surface and some sort of pigment. One person can do it. At the very least, in a rock band one would need a guitar, bass and drums. Right there, for

the band, you need at least three people to be involved. However, now with the advent of computer technology you really only need one keyboard to compose an entire symphony, so I'm not really sure that last point makes sense either. I believe it is the personal choice of the artist whether they create alone or in a group, regardless of the medium.

5 | The figures of star artist like Basquiat or Haring it's a model for the actual street artist?

Yes and No. I believe Basquiat and Haring were very important to the development of street art in New York. They were the first artists from the world of graffiti to gain international recognition in the art world. One could argue that there would be no idea of "street art" without them. However there were many artists on the West Coast, Raymond Pettibon would be a good example, coming out of the Punk movement who have gone on to have equal if not more influence now. We live in a different culture now though. Street art is an industry unto itself. There could never be

another artist like Haring or Basquiat. We are too culturally savvy as a culture now. Information is passed too quickly and an innocence that existed in those artists has been lost.

6 | Why did you call your international show "Beautiful losers" ?

The title is actually taken from a novel written by Leonard Cohen in the 1960s. It was chosen because many of the artists I like have come from cultures that are beyond the scope of acceptability and/or legality. I believe all the best art that has been produced throughout time comes from outsider communities. Communities that in the eyes of the establishment might be considered "losers." I liked the title because it suggested that if we really look beyond the surface, these people who exist outside of the normal status-quo actually have something quite beautiful to contribute to society.

Interview with Kiddy Citny

He now divides his time between Berlin and Munich. He exhibits in the galleries of half the world. He has every reason to be a satisfied man. Maybe he's something of a "worker" in retirement. This after having passed from the hardest showcase on earth, the Berlin Wall, to a situation – after it fell – that is far less elitist and far more within normality. There's reason to call him "worker", since he puts on a workman's face when he talks about himself and his relationship with the great wall.. To date Kiddy Citny has had two formidable transmission antennas to his credit: the first is the wall, which he consciously chose for his graffiti, whereas the second – the cinema – is something for which he was chosen. The image of Kiddy Citny, with the wall in front of him, interwove two great means of communication. In 1987, while Wim Wenders was filming this artist who painted thousands of metres of the Berlin Wall, he made a coup worthy of Duchamp: with a far from simple intellectual operation he sought to superimpose three levels of image: the wall, Citny's work installed on the first image and lastly the film image which accommodated the first two and made them fly. We met Kiddy Citny at his Berlin house in Brunhildstrasse. A house with nothing of the loft about it, no artist's open space but a corridor with rooms to right and left and a small bathroom and kitchen. In the studio, more than one desk and more than one computer but above all small and medium size pictures on the walls featuring his characters with their heart shaped or princely crowned heads. The titles speak clearly: "you lucky star", "feel fine", "imagine & set", response@responsibility, "2night", "dream / reality", "courage", p@ssion, "what time is love?", "lust-last-liebe", "l'amour toujours". The same simple and immediate metaphors of the Berlin Wall, communicating love and sharing, freedom and peace, sensitivity and tenderness, will and responsibility.

1 | The graffiti archipelago in its many forms, starting with the most anonymous right down to the most structured, has an elementary anthropological meaning. You're a good example of this. What did it mean to you to paint an ideological and highly symbolic construction like the Berlin Wall, a physical emblem of division between the capitalist west and the communist east?

Painting the wall on its western side

while being on socialist soil (the 3 metres in front of the western side belonged to the eastern bloc) meant that you were on extremely delicate terrain, and what you had before your eyes was the order on which world balances stood. The East-West conflict. I wanted to have my first studio there and publicly spread my "enfant miraculeux" universe. Maybe we were avant-garde precisely because we foresaw the fragility and provisional nature of walls. The practical execution was a sort of cat and mouse game between us and the Volkspolizei. We arrived with ladders, big buckets of paint, and had it not been art some might have thought we wanted to assault the wall.

2 | How much clear-sightedness and how much protest was involved in redesigning such a dramatic wall?

My awareness was pretty naïf. I wanted to paint my characters and translate into images the texts I used to write at the time, condensing them into a motto of a punk flavour: "we're so young we don't want to wait". The protest was against everything,

not political in a strict sense. If anything it was Robin Hood style rebellion.

3 | A gesture first existential then artistic...

Existential or artistic I couldn't say because at that time I wasn't fully aware of such things. I was impelled by "fuck art – let's dance". We wanted to give concreteness to our ideas. All artistic claims were alien to us or at the most we followed Beuys' dictum that "everyone is an artist".

4 | As a graffitist you worked in forbidden space. Having to work fast was a decisive factor in your action. Have you ever realised that you chose a fundamentally romantic space to carry out your actions? And subsequently, your having reached a global level of communication through the Wenders film which acknowledges you as a romantic hero...

The wall was hellishly ugly. We were so possessed by the painting, and the wall allowed itself to be modified so quickly, that I recognised the romantic aspect only afterwards. We wanted to transform the wall into an absurd construction, a fundamentally useless thing or at the best destined to crumble, as it did to everyone's amazement, but also to our great satisfaction, in '89. The "duel" was over and in a certain sense we could also feel that we had won.

5 | I know that you've taken legal action against people who pinched pieces of your painted wall to exhibit them in galleries and put them on the market. You felt that you and the spirit of your gesture had been betrayed... Don't you feel it's a bit much to claim property rights on something that belonged to the world and maybe inevitably to the market too?

Even before the wall came down we had beautified the city of Berlin with our paintings. For example there was the typical folding album of images in Waldemarstrasse that the bookshops used for advertising. Then there was an increasingly massive production of postcards, and coach loads of tourists who came not to see the wall but the graffiti on it. We weren't fully aware but underneath we already understood the importance of our copyrights. One day I went to get a catalogue of our works from a shop, but when I learned that it would cost me 40 marks I understood that everything had become excessive. All at once I realised that others intended to get rich through our works. Whereas we wanted to keep the wall as a memorial, preserved in its original version. This is why we even wrote to the then chancellor Kohl, comparing our situation to that of Guernica. But it was completely useless until I brought in

- ### Kiddy Citny

Born in Stuttgart in 1958, Kiddy Citny spent his childhood in Bremen and in 1977 went to West Berlin as a musician. He set up his own group (Sprung aus den Wolken) who worked with Nina Hagen and the Einstürzende Neubauten. Years swept by the long wave of the punk generation, but above all years in which history offered one of the biggest and most symbolic supports for a street painting that became a cry of freedom. The Berlin Wall, set right in the heart of a Europe divided into two blocs. Here, beginning in 1984, Kiddy Citny (literally city boy) painted his gigantic heart shaped faces, thus eluding, together with Frenchmen Thierry Noir and Christophe Bouchet, military control by the guards. Sunny faces which if on the one hand were framed by the playful positivity of a royal crown t be worn faithfully on the head, on the other hand supplied the most extreme contrast with the dramat grey of the context. Coloured metres that certainly could not pass unobserved by the eye of a direct like Wim Wenders who filmed him at work and gave him a cameo part in "The Sky Over Berlin". It is precisely these vital and passionate figures, reproduced on many postcards and widely photographed by tourists, that gained international fame for this German artist's friezes. It is no surprise that when the wall fell, and by means of operations bordering on bag-snatching, these monumental pieces ended up enriching the world's most important museums. The MOMA in New York still houses a block of an overall 100 metres. Since that fateful 1989 Kiddy Citny has wandered around various European and American cities (Vienna, Paris, London, Amsterdam, Zurich, Berne, Los Angeles and Munich), each time seeking new centres to which his vocation for research and experimentation can gravitate. Blocks of his part of the wall can be seen in Potsdamer Platz, Berlin, and in front of the United Nations headquarters in New York.

Berlino Wall
1998
Graffiti

a lawyer, Prof. Hertin, who is an expert in rights. Ten years of petitioning the Court of Cassation passed before we managed to obtain an appropriate percentage of the selling price, as well as acknowledgement that the case had created a precedent. Looking at things after the fact, the idea of German reunification has been an actual operation of economic exploitation of East Germany. Our "adversary" in the court proceedings was also the Federal Republic of Germany as successor to East Germany, so winning a verdict over your own state was a reason for pride. There's nothing to be justified here, in the sense that it isn't a case of greedy artists. Shame lay with the other party.

6 | What's your relationship today with city walls which are not that wall?
Cities that sanctify and consolidate their walls are the last bulwarks of stupidity. People who build walls die inside them.

7 | In 1985 Allan Schwarzmann, a street art scholar, identified writers and their tribes as children of a society that wants to communicate news as soon as it appears, using tags, writings and images at the level of personal telegraphs. How in general does art change when it hits the street, and how do you experience this process of redefinition?
When art hits the street a machinery is actuated which uses symbols and which immediately absorbs and markets the new street art. Then marketing principles are set in motion, so in the space of a couple of months this art too becomes part of the household – on cups, on carpets etc. – and if all goes well even the artist achieves recognition and fame.

8 | Walls are like blackboards, there's the recovery of the tribal sign. What future, what evolutions do you see for street art?
Street art will have trouble getting out of its dirty corner since it's still seen as a subculture, or even worse as the soiling of inhabited areas. For the ones who came after, all the young sprayers, almost every city has its anti-graffiti police. Only if street art risks something radically new will it be noticed, but that's practically impossible

due to the property laws. But anyhow, where there's a will there's a way. Here in Berlin there have been developments: cutting out figures on sheets of paper up to A3 format, specially prepared and treated against rain, which can be fixed to any kind of surface. This is already a sign of progress. Street art becoming more flexible. Time will tell whether they'll get as far as three-dimensionality or whether order will be imposed in the districts of the city with a guard for every house. A situation that would mean the isolation and criminalizing of street art.

9 | The cement wall has been destroyed but not the idea of that wall. Contemporary history has in fact identified precisely that wall, which has been demolished, as the watershed of world events which have affected us at close range. Indeed its physical destruction has increased the power of a symbol that is a potent transmitter of signals, perhaps even more so than art itself. Do you think, then, that you've suffered from the shattering of a situation which was wholly occupied by the wall in all its meanings? What would you reply to someone who thought you were the orphan of this situation?

I'd reply that I'm a child of the wall: it was built when I was born and it disappeared when I'd become adult. The wall was my painting school. There for the first time I could paint really big pictures. With its disappearance I was raised to the heights of recent history and my hearts have gone all round the world as symbols of reunification. So I'm happy that my "mum-dad wall" has disappeared and that I've grown up. I still see it when I pass by on my bike ...

10 | Can you tell me what you've been doing since 1989?

After 1989 I took advantage of the moment, exploiting the possibilities of being able to earn my living through art. Art needs care and attention. If I succeeded in getting into that circuit it was also due to gallery owners and publishers who saw my potential. So I've been able to exhibit in many parts of the world, continuing to investigate the infinite facets and circumstances of life. Long live art.

NOW
I BREA
YOU!

ZIO PORK!

SEXY
PIG

(Rovereto, 1980), real name Laura Scottino. She uses painting, computer and installation to create a personal universe, populated by characters similar to little monsters, from which emerges the influence of web culture, television, animated cartoons, the internet, comics, video games and sci-fi. An ironic elaboration of the contemporary and of the identities that comprise it. So we have dynamic and gaudy outlines of Batman type piglet-superheroes, flying yellow beaks, mummy ducks, dad ducks and sister ducks that simulate reality, manoeuvring between fiction and appearance.

opere
2005
acrylic and pen on paper
different sizes
Courtesy Galleria Perugi, Padova and
Studio Raffaelli, Trento

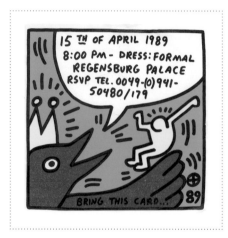

Keith Haring
record with cover for birthday invitation
Gloria von Thurn und Taxis
1989
print on paper and vinyl
cover 18 x 18 cm, record Ø 17,5 cm
Private collection, Bolzano

Keith Haring
untitled
1982
white plaster on black paper
59 x 86 cm
Courtesy Galleria Les Chances de l'Art, Bolzano

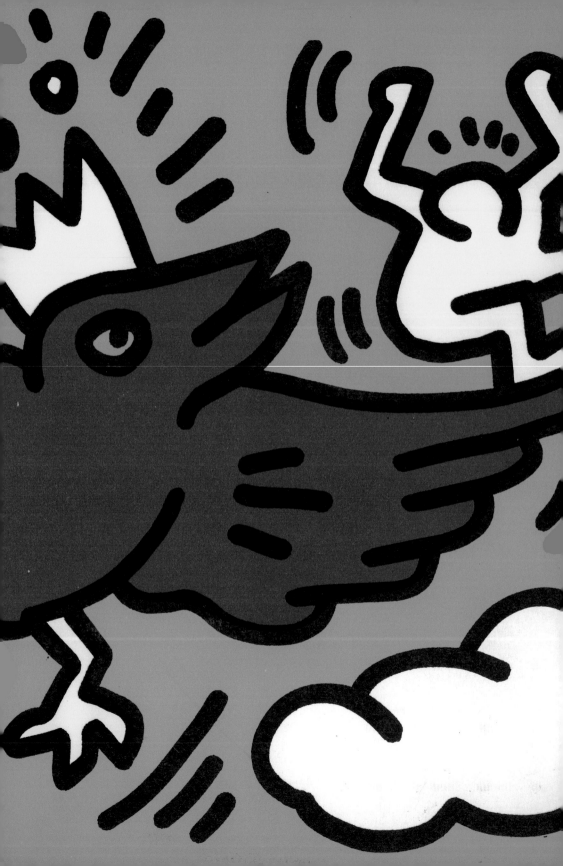

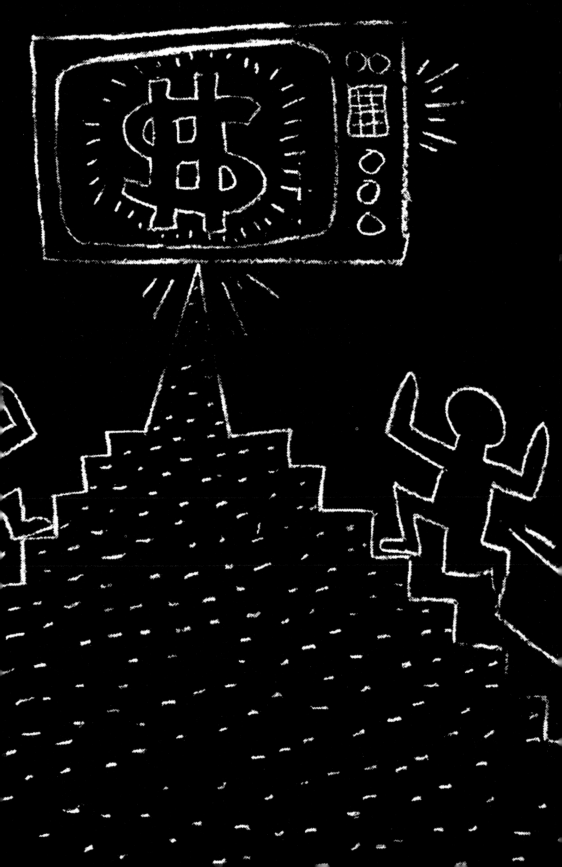

- Keith Haring

Born 1958 in Kutztown, Pennsylvania. His father was active as an artist in the field of comics and animated cartoons. With this example at home Haring, after high school, attended the "Ivy School of Professional Art" in Pittsburgh for six months but, dissatisfied, he went hitchhiking all over the country and on his return enrolled at the University of Pittsburgh in 1976. Shortly afterwards he got involved in the "Pittsburgh Art" project and the "Crafts Center" where he had his first important show. At this point, influenced among others by Warhol, Dubuffet and Alchinky, Haring began his official career. But the big step forward came when, having moved to New York, he drew attention with small urban works – spontaneous and "illegal" – done on subway advertising panels. In 1982, in Times Square, he exhibited his luminous poster which at regular intervals (thirty seconds every twenty minutes for a month) displayed his electronic images. Then with Kenny Scharf he organised the "Drawing Show" at the Mud Club with performances, rap music, dance of the surfers and the electric boogie (electrical charge passed through the limbs, causing the body to react with schizophrenic gestures, remotely controlled by the convolutions of the brain). One of the founders of a popular art which, following the "All Over" concept had to be everywhere and for everyone, Haring painted not only panels, underground walls, hospitals, churches, business premises and discotheques but also everything else that came to hand: cars, shoes, T-shirts and various objects. Consecration came with the opening of his celebrated Pop Shop in 1986. He made primitive and cubist masks, great terracotta vases, totemic sculptures in metal and in wood with pictograms. He created the ten by ten metre square stage backdrop for the New York Palladium, temple of nightlife in the 80's, and the one for Roland Petit's "The Marriage of Heaven and Hell" for the Ballet National de Marseille. He exhibited at the best New York Galleries, at Documenta in Kassel and at the Biennials of Venice, the Whitney and Sao Paulo. It was 1987 when he said: "I've done a lot of things in my life, I've made a lot of money and had lots of fun. But I also lived in New York in the years of sexual promiscuity. If I don't get AIDS, nobody will get it." And three years later the disease killed him. So only one decade of artistic activity, from 1980 to 1990, but Haring exploited it to the utmost. He compulsively unleashed his bestiary of stylised figures: childlike drawings, kids crawling, little men that embrace, love, dance and kiss, pyramids, flying saucers, and dogs barking at the TV set or the images on posters. The whole to radiate pure and active élan vital, to spread the pulsation of Eros as creative energy, to celebrate sexual freedom, to promote campaigns for the use of condoms and against crack, intolerance and discrimination with regard to homosexuals. This he did through references to the iconographies and themes of western art from the Middle Ages to the 1960's, and of African, Asian and South American tribal cultures, in particular pre-Columbian civilisation. His is a frenetic art that shows itself directly, unconditioned and uninhibited, often mistakenly seen as more of a media and political phenomenon. Keith Haring embodies the coloured and symbolic shooting star of the 1980' artistic and social parabola, where "a wall is made to be drawn on, Saturday night is for partying and life is made to be celebrated."

Chris Johanson

Born in 1968 in Los Angeles, his work is solidly linked with the "Mission School", a quarter of
n Francisco where a community of artists, writers and intellectuals - including Barry McGee - live
d work together in the name of an urban realism of denunciation and commitment. Johanson's political
d social painting, taking inspiration from graffiti art and comics, and in a direct almost naïf
yle, presents us with ranks of businessmen, hippies and ordinary people: a critical mirror of the
oblems of modern life.

Untitled
2004
acrylics on wood
26 x 35,5 cm
Private collection, Milano

Untitled
2004
acrylics on wood
37 x 33,5 cm
Private collection, Milano

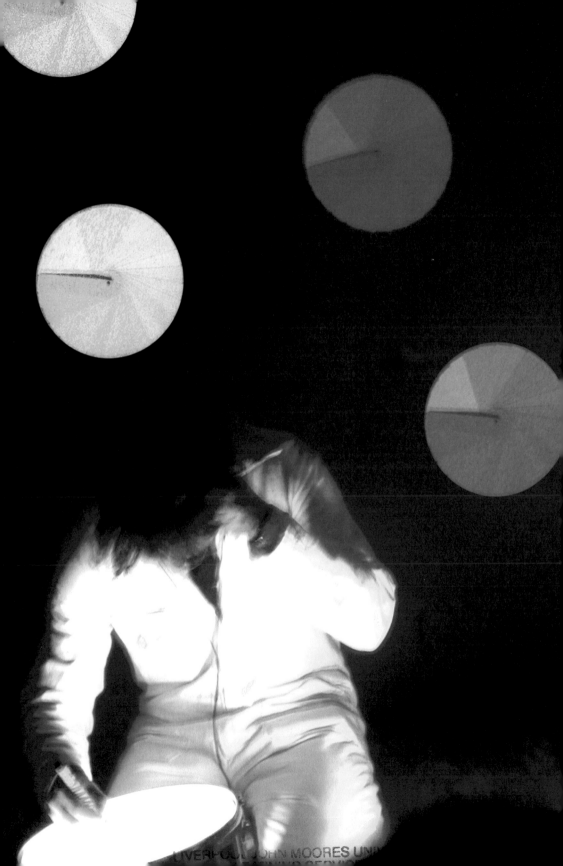

- Andrea Renzini

-
-
- Overture
-

Does colour have a sound? The musical timbre of the early 20th century presumes so by analogy. When John Cage hypothesised an art of colour without theory, he certainly had no presentiment that from the death of painting we could arrive at the death of colour, that of the pantone (through exhaustion and consumption). The dis-engaging that Andrea Renini carries out on it is polyrhythmic polyphony. This dynamism has in itself a twofold aspect: adopting colour to adapt it to music: chromatic sound formlessness that mirrors the gestural symbiosis between music and colour of Jackson Pollock's action painting with John Coltrane's New Thing. Renzini's performanc electronically manipulated by Stefano Passini, comparable to a cynical endeavour, summarises bo aspects. Exploiting the friction of the pantone on a sheet of paper or on amplified instruments he crosses over an ensemble of genres and styles, breaking the silence of Cage's "action music", restoring volume and colour to the murmur of painting. On the splendours of Russolo's "Daredevilry" it actually appears that the interactions between visual arts and sound continue unperturbed to intone concreteness of the real.

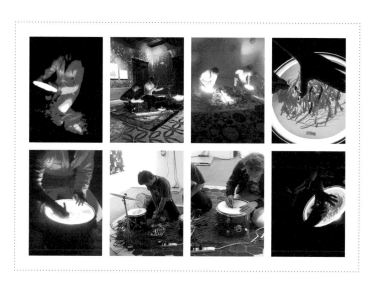

Sonic set from consumed pantone
2006
sewn photographs
Courtesy NT Gallery, Bologna

• Barry McGee

Born 1966 in San Francisco. A second generation graffitist he began his career in the 80's , working on the street under various acronyms – Prog was the first – or signing with the pseudonym Twist. On walls and shutters he painted his "Leitmotiv" of fragile, melancholy and decadent looking figures, and created stickers and T-shirts with logos against cloning and military violence. He later went on to reworking scrap material, including demolished cars and old signs, to reflect the contrasts and evils of urban life. All bearing witness to alienation, unease, anguish. In 2001 at the Corderie dell'Arsenale during the Venice Biennial, directed by Harald Szeeman and entitled "Platea dell'umanità", McGee together with Stephen Powers and Todd James, made a realistic reconstruction of a Street Market, complete with immigrants selling fake designer goods. His work is in international museums and galleries and is included in the recent itinerant exhibition "Beautiful Losers" in Milan and at the Fondazione Prada.

Untitled (12 Pieces)
2004
painting on panel
120,45 x 130,27 cm
Courtesy Collection Ernesto Esposito, Napoli

- Toxic

Born 1965 in New York he lives in Italy and France. He belongs to the second generation of graffitists that emerged in 1978 and he took part in the great "Time(s)?? Square Show" in New York which included Toxic, still an adolescent, Ramm-ell-zee, Ronny Cutrone, Samo (J.M. Basquiat), A-One and Crash, as well as various subway gangs. Since then he has exhibited at all the international graffitist shows.

The mover
1987
mixed technics on canvas and wood
160 x 162 cm
Courtesy Sergio Tossi Arte Contemporanea, Firenze

Max Rohr

(Bolzano, 1960). His is a mental painting that absorbs languages from television, video,
mics, advertising and cinema. In a neutral and aseptic manner Rohr strikes his own narrative key in
rtraying, or better, X-raying the human figure with bodies-torsos which, somewhat like an intestine
ndow, open up on an interiority consisting of bourgeois settings and slices of the metropolis.
hr's contemporary man sees and touches everything but may also look at and touch himself, setting
t from the assumption that the body and things are made up of the same fibres.

Honky Tonkin'
2006
oil on canvas
170 x 190 cm
Courtesy Sergio Tossi Arte Contemporanea, Firenze

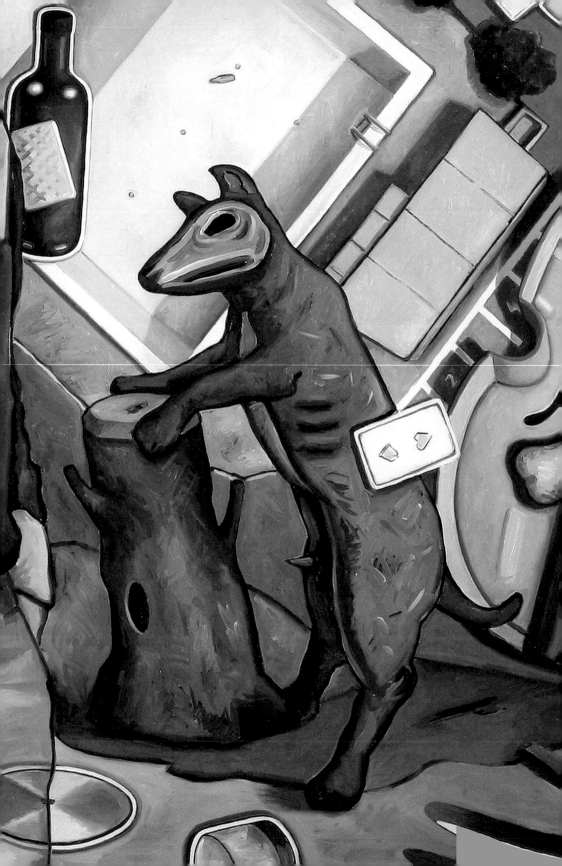

- Ramm-ell-zee

Pseudonym of the Afro-American artist Stephen Piccirello (born 1960 in Far Rockaway, Queens, New York), a leading exponent of black protest graffiti who grew up in the ghetto. His spray response to large scale mass productions had the effect of subverting their communication and overturning their message. "Ramm-ell-zee is twenty-four, tall, thin, emaciated… he emerged from the Subway labyrinths with a pamphlet, works of painting and sculpture, and a voice which at rap concerts shout out the bickering of cartoon ducks," wrote Francesca Alinovi in 1983. Originator of the theory of "armed letters" or "iconoclastic panzerism" or "gothic futurism", he pressed on to the re-foundation of language on "disciplined and disciplining" bases. He mixes terms drawn from semiotics, physics, mathematics and nuclear conflict with the slang of the blacks and the tribes of the emarginated. He applies his conceptual challenges to his own graphic experimentation in which he uses paint, mirrors, Plexiglas and resin, mixed techniques on paper. A connoisseur of calligraphic styles, under the gang leader name of "Master Killer" he transmits laws to his followers, those young "guerrillas of the word" who call themselves A-One (the sharpest of Ramm-ell-zee's followers, assigned to the defence and reinforcement of the letter A in the rigid and hierarchical military organisation of his army), B-One, C-One. He does his performances with them, often dressed up as a gangster. Calling himself "Gangster Duck" he fires volleys of words at the microphone with rhymes and hyperbolic verbal inventions, parodying the slang of the comics. In his works Ramm-ell-zee gives a glimpse of all the stores of language he refers to: from pop to comics, futurism and sci-fi films; he evokes nebulous astral projections, but all of them introspections of the mind. He stains surfaces with a fine dust of colour, often black, red and orange, and marks directions on old yellowed maps of the treasure island type. In 1983, among other things, he recorded Beat Bop, a classic of Hip Hop poetry, which was produced by Jean-Michel Basquiat. At the 2005 Venice Biennial he presented the world premiere of a kind of sermon, one hour long and entitled "Bi-Conicals of the Ramm-ell-zee": on that occasion, at the Teatro alle Tese Cinquecentesche, Ramm-ell-zee proclaimed the general plan of action for his "gothic futurism" which aims at forming a world founded on new aesthetic and political orders. His influence has extended to innumerable rappers including the Beastie Boys and B-Real. He still moves around between New York, Berlin, Munich and Tokyo, continuing his activity as a performer, rigged out as a futuristic samurai or a post-atomic survivor. A "neo-amanuensis" as critics have defined him. His music is a sort of illuminated manuscript of sound neologisms and electronic syncretism. It isn't at random that Ramm-ell-zee appears on his disc covers wearing modern plastic technological armours, hi-tech discards. These are the many sides of a biography which is complex right from his choice of pseudonym. He explains it himself as the result of an actual "military equation": "Ramm plus the elevation of X to Z".

The shot from under
1983
spray painting and collage on cardboard in 4 panels
75 x 100 cm (single panel)
Courtesy Collection Carlo Palli, Prato

- Bartolomeo Migliore

Born in Santena in 1960, he began painting in the 80's in Turin, inspired by traditional American graffitism and contemporary metropolitan underground movements. Imbued with the punk, Goth and metal sensibilities of the period, Migliore interweaves music and painting in a language made up of acrylics and pencil on canvas, gloomy backgrounds from which emerge symbols and letters in the acid colours of Californian graphics and used in the same way as slogans, samplings of sounds drawn from Placebo, Smashing Pumpkins and David Bowie. For some years now he has been opening up new frontiers of research through the insertion of Arabic and Indian characters.

Garage 9
2006
acrylics and pencil on canvas
170 x 220 cm
Courtesy Galleria Pack, Milano

- Blu ed Ericailcane

As is usual with street-artists, we have little biographical information about Blu ed Ericailcane. They're under thirty, live in Bologna and operate on the world's walls with their pseudonym-signatures, maintaining the anonymous and collective feature of international graffitism. Starting in 2000 their collaboration has been reinforced by shared aims which favour the social and political influence of their interventions. Actions whose main purpose is to reclaim public spaces and recover rundown and abandoned places in order to insert the anatomy of an existential denunciation. Not a violent clash with an enemy whose face is clearly defined, but with the humanoid drift of a standardised reality prey to forced mechanisation. And it is precisely in this context th contemporary parasite-man comes into friction with the machine, embracing the neurotic expressioni of an imagination (and everything related thereto) which has reached its technological twilight. Arms raised, jaws open and tongues hanging out, due to a condition of impotence already visible in their early murals, dated 2000, in Bologna's Via Mascarella and Via Stalingrado. A hybridised and alarming universe which in subsequent works (from Barcelona and Malaga 2001 down to the various graffiti festivals of Grosseto, Modena and Florence 2004) gets increasingly crowded, enclosed in tubes behind gasmasks, bursting into animal pens and transforming humanity into a robotic patrol on its way to dispersion. Among cinematic references that bring in Fritz Lang type atmospheres and disturbing experiments in Cronenberg style, Blu ed Ericailcane, maintaining adherence to a post-human aesthetic, also arrived in South America. More precisely Nicaragua where they took part in the 2005 "Murales de octubre" festival to recall the paintings symbolic of the Sandinista revolution an at the same time protest against their erasure.

College Crash
1988
spray painting

- Ari Marcopoulos

 Born in the Netherlands, he moved to New York in 1979 and began to work, printing Andy Warhol's
photographs. Immersed in the artistic and musical atmosphere of the 80's, he photographed both
ordinary and famous people, building up a collection of documentary type shots, but also particularl
intense portraits such as the extraordinary ones of Jean-Michel Basquiat. "Out and About" goes back
over more than twenty years of New York history which Marcopoulos always experienced in contact
with street culture: Graffiti, Hip Hop, Rock and alternative sports such as Skateboarding, signs
of a moving away from socially accepted conventions and patterns. Marcopoulos' photos represent
the Punk counterculture, Rap (his recent work, which took five years, following the Beastie Boys'
world tour) and the drug and gay subculture. These marginal, borderline communities find important
testimony in the work of Marcopoulos, with his ability to totally immerse himself in such realities
in order to best capture them. Ari Marcopoulos' art may be framed in the context of Public Art in the
sense of being a profound work that represents the real, very close to performance art rather than
to photography as an instrument of documentation. It is first and foremost an action, a gesture of
inquiry.

Andy Warhol
1981
Courtesy of the artist

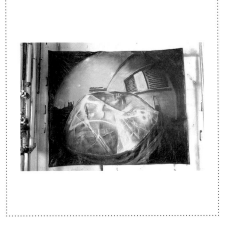

Cuoghi e Corsello
Via Mazzini
2003
300 x 245 cm
spray painting on canvas
Courtesy of the artists

Cuoghi e Corsello
Paesaggio n. 6
1994
spray painting

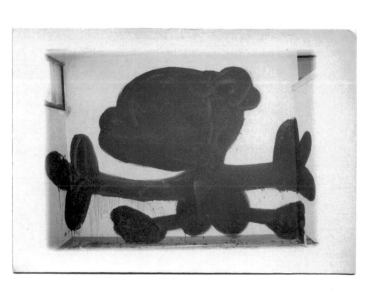

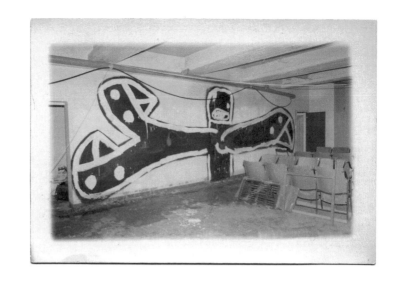

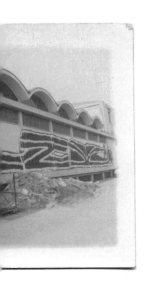

• Cuoghi e Corsello

Monica Cuoghi (Sermide, 1965) and Claudio Corsello (Bologna, 1964) live in Bologna and have been working together since 1986. Two of the first Italian street artists, they invaded the walls of the city with the outlines of characters that soon passed into the collective imagination: from the historic goose (Pea Brain), with her stylised long, flaccid legs, to the dreamy little girl with big ears (Suf oppure Sufi??), by way of the static adventures of the tired dog (CK8). Though the sizes of the drawings are varied in a serial nature that disdains neither the gigantic nor minimum scale, the immediate recognisability of these "puppets", created either with sprays or the use of stencils, made these artists' "tag" (signature) reach the heights of an urban myth. The Cuoghi Corsello duo's work is a figurative rewriting which has always fed on heterogeneous means and materials: though they have remained faithful in an evolutionary context to the iconographic graffiti of the early days, over the years they have added, in a complementary way, performance and sound interventions, video, photography and installations. The eclectic testimony of a stylistic cipher that does not want to feel tied to only one expressive area. Of course their experiences certainly cannot be separated from the generational trajectories that characterised Bologna in those years. An underground itinerary made up of early exhibitions in independently run spaces and social centres, until the leap in 1991 when they had their own personal show at the city's Neon gallery, entitled "Corso di arricchimento dello spirito" (Course for Enrichment of the Spirit). Among their other main personal and collective exhibitions: Nuova Officina Bolognese, Galleria d'Arte Moderna, Bologna (1991), Galleria Neon, Bologna (1995), XII Rome Quadrennial (1996), Officina Italia, Galleria d'Arte Moderna, Bologna (1997, Salara, Bologna (1999), Studio Ercolani, Bologna (2000), Municipal Gallery KetS, Berlin (2001), Museo del Corso, Rome (2002), Galleria Civica di Arte Contemporanea Trento (2003), Rocca Sforzesca Imola (2004), Guido Costa Projects, Turin (2005).

Terrible Story of the Talented Boy | *A rock Fable*

Louis Böde | Not so long ago, in a country similar to ours, there was a tree covered hill. It was high and solitary and as the sun moved around it left the hill eternally divided in two: half in light and half in shadow.

One day a governor happened to pass by. He saw all those trees and decided that they served no purpose. They cut down the trees but the bare hill now seemed stark and defenceless, like a body with no skin. Then someone else said that it should be protected. They built a fortress. Actually there was nothing to protect and the fortress stood out useless at the top of the hill, far from any human presence.

The fortress became a factory. It was enormous and in production every day round the clock. It churned out shoes, dolls, hams, spectacle lenses, psychotropic drugs for animals, headless matches. In fact it produced all sorts of things. But when the factory went bankrupt, silence once more reigned on the hill. The wind whistled through the walls of the ex-fortress. The sun moved around it. It took time before someone decided how to fill that vacuum. A headmaster was appointed. Pupils arrived.

The fame of the school on the hill, so grand and promising, soon spread. So that afflicted place seemed at last to have found its definitive use and the fortress become school filled up with young souls.

* * *

The pupils in the ex-fortress had no pastimes. There was nothing but the dry wind up there. Since the hill was isolated and the wind would absorb noise as the ocean sweeps away debris, the kids started to make music. They played guitars shiny as diamonds. They shot their notes skywards. They sang every day and every night. They got together in the big courtyard and challenged one another to sing the angriest or the most melancholy song.

The headmaster couldn't stand the kids' music. He thought it purposeless and in principle thought of prohibiting it, but then he had second thoughts. Unbeknownst to the pupils he started recording their performances and selling discs to the world outside, with enormous success.

The headmaster became increasingly rich.

The myth of the fortress-school spread everywhere. That tormenting music worked like a spell and the school attracted more and more pupils. But the headmaster didn't feel satisfied because no matter how many pupils arrived the ex-fortress was still too big. It would have been impossible to fill it up as simply a school. And this detail bothered him, a shard of glass in his ambitious heart.

* * *

One of the pupils was a talented boy. When he picked up a guitar the hill vibrated. When he filled his lungs even the wind seemed to fall for a moment, surprised by his voice. Talent lived in him as fire lives in the earth. The Talented Boy had been there for a long time, ever since the school had opened, and he had never left because the hill was far away from everything and the kids in the ex-fortress seemed to have all they needed: food, education, clothes, music. Generally on arrival the pupils immediately forgot what they had known before the hill, and if they surveyed the view from up there all they saw was fog, distance. All that remained in them

was a vague trace, a nameless nostalgia. The Talented Boy felt a deeper nostalgia than the others, and this is why his songs were more beautiful, this is why he sang them more powerfully. He suffered for every line. Was reborn in every note.

One day he wrote a perfect song but he needed the last word to complete the lyrics. Just one word, a final sound to bring the song to a close. He agonised over it for days, without finding it.

* * *

There was a forbidden word in the ex-fortress. The headmaster encouraged the pupils to play music but forbade the use of that word in their songs. The forbidden word was soft and cutting, it filled the throat with a special sound. It penetrated the soul. But since it was prohibited nobody used it. Nobody thought it was so necessary or that there was a need to break the rule. Everybody knew that at bottom a little obedience was a help in living there.

The Talented Boy had long been seeking his missing word. He'd thought and thought,

and only in the end did he realise, with amazement, that it was precisely the prohibited one. There was no doubt about it. His song needed that word for completion. The boy, troubled, continued to think about it. He had dreams where the word entered his ear, deafening, and tore his heart. He had dreams where the word opened up the sky, moved the planets with the power of its echo, shook the earth so violently that it brought forth the bones of the dead and its hidden treasures. With that word everything seemed possible.

* * *

One evening at sunset, having spent days in meditation, the Talented Boy met up with the group he usually played with. They went into the central courtyard where they were welcomed with great enthusiasm. Everybody knew there was a new song. As the sun died along a flank of the hill they took up their instruments and started to play. And the Talented Boy sang his song, and everyone stayed to listen.

It was clear right away that this was a special piece. The headmaster listened with satisfaction, already thinking of the money he'd make selling this marvellous song to the world outside.

Then with the last line of the song the Talented Boy enunciated the word. He sang it with such power that everyone was astounded. The hill vibrated. The wind went still. Everything was motionless as if before a storm.

In the tower the headmaster stood stiffly, almost dumbstruck. His staff expected him to explode in a howl of rage and revenge, but he kept calm. He summoned them around him and said: I've got a great idea.

* * *

The headmaster had long been tormented by the fact that the ex-fortress, being so big, was impossible to exploit to the full. Moreover he had always wanted, in reality, to be governor of a prison. Now, thanks to the Talented Boy's rebellion, he had the chance to make his dream come true.

The school was divided in two. A second surrounding wall was built internally to the one that already surrounded the ex-fortress. On one side of the wall the school remained as before, while a prison was created on the other. From his tower the headmaster could observe both sides and feel his breast swell with satisfaction, because there was no longer any wasted space and everything was running perfectly. School and punishment stood side by side.

The Talented Boy was the only prisoner, but his presence was enough to give meaning to the prison. Every day before dawn the jailers came to wake him, impatient that he should

stop dreaming he was free and return to awareness of being a convict.

He was not allowed to sing. He had to work. Many of the school employees had been transformed into prison workers and spent the day guarding the prisoner, while the Talented Boy, in chains, carried out the work that had formerly been theirs. He dug holes for burying garbage. He constructed new plumbing pipes. He milled flour for the school kitchens. The days were long and wearisome. By now much of the running of the ex-fortress depended on his forced labour.

* * *

The Talented Boy worked every day till after sundown. Then he could lie down for a few hours on a cot in a roofless shed. He gazed at the icy, distant moon. At those times he dreamed of striking up his song, but only in his thoughts because the jailers kept him under surveillance also at night in order to prevent him singing it.

He felt lost. He thought of his friends beyond the wall. Special soundproofing had been installed so that he would not hear the songs and music of his old schoolmates. That silence was the worst of all prison punishments.

He couldn't believe that all this was happening to him, precisely to him, because at bottom he felt that he had made no choice. He had done the one thing possible, completing the only possible song with the only possible word.

* * *

The Talented Boy was not alone for long. The prison began to receive new convicts. The first to arrive was a fat boy. Did you say the forbidden word? the Talented Boy asked him immediately. But the fat boy had merely stolen food from a schoolmate.

They arrived in ever greater numbers. Boys poured into prison like rain into a gutter. You got jailed for stealing food, for lacking respect, for smiling at the wrong moment, for not having smiled at all. You got jailed really for everything. Once inside the prison it was hard to get out, and those who ended up in prison remained there for ever. There was no lack of forced labour, since over and above the maintenance work of the ex-fortress the inmates now manufactured the discs of the pupils' songs.

The discs sold increasingly in the outside world. The fame of the fortress-school was at its peak. And new students arrived in ever greater numbers, unknowing, attracted by that place where you learnt to give free rein to your talent. In the ex-fortress, they thought, there's room for everybody's talent. They moved into the school, forgot about the outside world then ended up in prison,

Outcast of the Universe
Commonstealth Omniabsence & Parallel Living
Cover: Thomas Feuerstein
Martin Philadelphy, Cristoph Grissemann
Stefan Bidner,
Christian Martinek feat. Philipp Quehenberg
Talibanrecords for medien.kunst.tirol.2005

It's getting cold in NYC
Hans Weigand, Stefan Bidner, Christian Martinek
Cover: Hans Weigand
Taliban records for medien.kunst.tirol.2005

They set up a clandestine music group. They weren't able to actually play but they could do so in their heads, and do it together. While they worked or ate, or when the others were asleep in their cots, they composed in code. A raised hand was A major, a feigned cough was C major. They wrote dozens of imaginary pieces together, executed grandiose mute concerts. Their music was so intense that it wasn't necessary to hear it. The music was within themselves, in their heads, in their imprisoned boys' hearts. They called themselves Kids&Revolution. One day, they thought, they'd bring out a disc under that name.

* * *

and at that point they sometimes even forgot about the school. It was a kind of chain, a destiny of amnesia.

* * *

The Talented Boy did not forget. He knew that over there in the school there would soon be a great music competition, the most important one of the year. The thought made him desperate. He couldn't bear the idea of not being able to take part. All his life he had wanted to sing, and being unable to do so deprived his life of meaning. So he decided, simply, to kill himself at the first opportunity.

But he immediately changed his mind. There were some prisoners who, like himself, had not resigned themselves to their fate. When the Talented Boy found out that he wasn't alone he invented a sign system for communicating with several fellow inmates.

The clandestine group was discovered. Maybe they had been imprudent or maybe someone had betrayed them. The governor appeared in person and, looking them in the eyes, pronounced his terrible sentence. The boys were tortured for seven days and seven nights. Seven nails and seven teeth were extracted from each of them. They broke each one's bones in seven places and placed electrodes in his seven orifices. Each one was crucified seven times and left for hours under a merciless sun and baptized seven times in icy water from which he was removed only seconds before drowning. Since the jailers got bored with their work, many of them asked if they could become torturers, but only seven were appointed. And each of the seven took the name of a musical note, laughing as they inflicted the most atrocious punishments. At dawn on the eighth day the governor asked each of the prisoners if he had

repented. All of them, with hardly a voice, answered yes. But not the Talented Boy. Another seven days of torment began for him. The first day they ripped the skin from his leg. The second day they ripped the skin from the other. The third day they skinned his arm and the fourth day the other arm. The fifth day they ripped the skin from his chest and stomach. The sixth day they ripped the skin from his back. Lastly, on the seventh day, they ripped the skin from his face but in spite of this he did not die.

The governor returned and, observing that miserable skinless body, asked him: well, do you repent?

The Talented Boy wanted to say no, but the unspeakable pain had made him mute. Here the torture ended.

* * *

The Talented Boy no longer had any skin. He was a body of living flesh. Wherever he lay he left patches of blood and pus. Without protection everything caused him double pain: the fire of the sun, the cold of the night. Even his nostalgia was now more heartfelt, blown by the wind, and with it his rage and obstinacy. He had decided to live, and to sing again.

But the Talented Boy was once more alone. Nobody was willing to conspire with him. Nobody was willing even to approach him. His uncovered flesh stank of blood, of hell. Everybody thought him mad, because no one could have survived such torture without going mad.

The Talented Boy couldn't sleep. His flesh burned continuously, and at night he gazed at the sky. Unfortunately the moon was no longer visible. Gleaming spotlights had been lit over at the school, in preparation for the great music competition, and their reflection obscured the sky. The competition was due to take place shortly.

* * *

The Talented Boy seemed finished. The Talented Boy seemed mute. The Talented Boy seemed mad. But his mind was working and he organised a plan.

One of the prisoners' tasks was to slaughter animals for the school kitchens. Every day great loads of meat were transported from the prison to the school. The Talented Boy managed to elude the jailers and slip into one of the loads. Amid all that bloody meat his skinless body was camouflaged. Keeping his head hidden behind the belly of a butchered animal, the Talented Boy felt the load being shifted, taking him towards the other side of the wall, towards the chance of singing again and towards the longed-for music competition.

But once again the jailers were more cunning than him, or someone had betrayed

him. Just when the load was going through the gate that linked the two parts of the ex-fortress the Talented Boy was discovered, captured and taken back to prison.

The governor came down from his tower. He pretended to think for a long time but he had actually decided beforehand: as you have continued to disobey, I sentence you to death.

* * *

The execution was to take place without much delay. There was no possibility of appeal.

Meanwhile news about what was happening in the prison had begun to circulate around the school. A lot of pupils had seen their schoolmates disappear into thin air, and they wondered how things were beyond that wall.

When the news arrived that the Talented Boy had been condemned to death, some did not believe it, whereas others felt highly disturbed. They talked about it between one lesson and the next, between one party and the next. The members of the Talented Boy's former group, on learning that their old companion had tried to escape in order to play music with them, decided that some reaction was called for. They wanted to do something. They wrote a song against the death penalty.

It was a huge success. With that song the group won the famous competition. Everybody recognised it as a great piece. It sold millions of copies worldwide and the group members became stars. The song didn't alter the Talented Boy's sentence, but they were all pleased nonetheless.

In the prison that great success had meant an increase in forced labour. The convicts slept for no more than two hours and they ate standing up, without interrupting their work. The world wanted that disc, that hymn to freedom, and the convicts had to manufacture it.

The headmaster-governor was beaming. He'd become even richer. By now he could have replaced every brick of his tower with a solid gold ingot. From on high he observed his kingdom. He looked at that place which was so divided yet united, that citadel which was half school for young talents and half prison for young criminals. He felt moved. It seemed

a perfect kingdom, practically eternal.

* * *

The day finally came.
The wind did not blow. The sun remained
hidden behind a veil of clouds, almost as if
fearing its emotions. Resounding trumpets
blasted at midday to announce the moment
of execution, and the prisoners were
confused, almost frightened, because they
hadn't heard an instrument for so long. They
were mustered to witness the execution.
The Talented Boy was escorted before the
executioner. The latter smiled, happy,
because this was his first day at work and he
intended to make a good impression.
They seated the prisoner and strapped his
wrists and ankles to the electric chair. The
executioner didn't ask the prisoner if he had
last words to say, because he thought him
mute. He then exchanged a glance with the
governor, who was observing the scene from
the tower window, and finally he threw the
switch.
The current invaded the Talented Boy's body.
It made his eyes boil and his flesh smoke. The

discharge lasted a long time but the prisoner did not die. Indeed his mouth opened in a smile and an unmistakable sound issued from his throat.

The discharge terminated. The Talented Boy's body was half-burnt but he was not dead. The executioner was dumbfounded. The prisoner where shocked. Beyond the wall the pupils too, who had understood what was happening, waited with bated breath. The governor was furious but did not show it. From the heights of his tower he made a sign to recommence, and the executioner returned to throw the switch.

Seven times the executioner threw the switch, for a longer period each time, and seven times the Talented Boy refused to die, each time singing at a very high, terrible pitch, each of the seven notes. In the ex-fortress everybody heard him and began to feel a growing fear, because the Talented Boy's voice seemed to belong to a devil or to an angel of death.

Then came the eighth discharge, so high that it used the energy of the entire hill, and as the prisoner's racked body trembled as if on the point of dissolving, a word issued from his breast, screamed in a powerful voice never before heard. It was the forbidden word.

That tremendous chant spread everywhere, hanging over the hill like a cloud. And on hearing it everyone went immediately crazy, overcome by an unknown fury, and sought some kind of a way out. The jailers deserted their posts. The prisoners started knocking down the walls. The pupils on the other side did the same, but when the wall was down and they were all reunited, the terrible chant continued. Then they demolished the external walls and suddenly realised they were free. Shouting, they ran down the hill and everyone went back to where he had come from.

The Talented Boy was still in the electric chair and the current was still torturing him. Perhaps he was already dead but his throat did not cease its chant until the headmaster-governor, driven crazy, threw himself from the tower and died.

* * *

Anyone going to that hill today would think it impossible that all this could have happened. Trees cover it once more and the ruins of the fortress are hidden amid the green. The walls no longer exist. The Talented Boy's bones are no longer here because over the years people have come up and taken them away to make flutes and other exquisitely sounding instruments. What more can I tell you? If you climb the hill now your ears will hear only the wind. Kids&Revolution never recorded any discs. As for the forbidden word, no one remembers it any more.

Chronology

	Pop, Street e Graffitti Art	Music \| *Rock, Free Jazz, Beat, Pop, Rap, Hip Hop, Punk, Fluxus*
1954	The British critic Lawrence Alloway invents the term Pop Art, meaning Popular Art.	Little Richard's *Tutti Frutti* and Bill Haley's *Rock Around The Clock* give birth to Rock and Roll.
1956	An exhibition at London's Whitechapel Gallery entitled *This is Tomorrow* marks the birth of Pop Art. Richard Hamilton exhibits the collage *Just what is it that makes today's homes so different, so appealing?*, the manifesto of English Pop Art.	Charles Mingus records his suite on the history of man *Pithecanthropus Erectus* and a singular version of *A Foggy Day (In London Town)* which he situates musically, with extraordinary sound effects, in the port of San Francisco. Already Pop Art.
1957	The English artist Richard Hamilton, with the sculptor Eduardo Paolozzi, defines the features of Pop Art: mass-produced, transient, easy, gimmicky, sexy, glamorous and Big Business. They are part of the Independent Group set up within London's Institute of Contemporary Art	
1959		Cecil Taylor records an overwhelming version of *Love For Sale*, another song transformed into avant-garde music
1960		On 21st December Ornette Coleman records *Free Jazz*, a collective improvisation for double quartet. On the cover, *White Light*, one of Jackson Pollock's last masterpieces

1961	Pop Art arrives in the United States, backed by Leo Castelli's gallery, Richard Bellamy's Green Gallery downtown and Martha Jackson's Uptown Gallery. Warhol exhibits his first works in the windows of the Bonwit Teller department store.	In November Bob Dylan releases his first album, *Bob Dylan*. The Beatles debut at the Star Club in Hamburg. John Cage publishes *Silence* in which he puts forward his musical poetics. Steve Lacy with Don Cherry records *Evidence*, a reworking of Thelonious Monk's compositions.
1962	First big public debate on Pop Art at *A Symposium on Pop Art* linked to the exhibition *Recent Painting in USA: The Figure*. The American gallery owner Sidney Janis organises a huge exhibition *The New Realism* which brings together everyone adhering to the spirit of Pop Art in Europe and America. It includes works by the Italians Mario Schifano, Enrico Baj and Tano Festa. Andy Warhol considers the artistic image as any kind of consumer image. The favoured technique is silkscreen. Serial images of consumer products appear, the first being the *Campbell's Soup Cans*. At his first solo show at the Green Gallery in New York, James Rosenquist sells all the exhibited works.	The Beatles go to the top of the British charts with *Please, Please Me*. In December the Rolling Stones cut their first record for Decca. In Chicago Muhal Richard Abrams forms the Experimental Band from which New Jazz grows. Albert Ayler experiments with the first Free Jazz in Sweden. Wiesbaden hosts the first *Fluxus Internazionale Festspiele Neuester Musik* at the *Hörsaal Städische Museum Wiesbaden*: 14 concerts featuring Higgins, Knowles, Paik, Williams, Köpcke, Vostell, Filliou, Maciunas, Patterson and Andersen.
1963	Warhol sets up the Factory on 47th Street. Shoots his first film *Sleep* which is followed by others. Meets Duchamp. Paints the *Green Coca-Cola Bottles* and the serial images of the *Mona Lisa, Liz Taylor, Marilyn Monroe* and *Jacqueline Kennedy*. George Segal shows his sculpture at the Ileana Sonnabend gallery in Paris.	*Festival Fluxorum Fluxus*, at the Kunstakademie in Duesseldorf, features George Maciunas, Nam June Paik, Emmet Williams, Dick Higgins, Wolf Vostell, Daniel Spoerri, John Cage, Yoko Ono and Silvano Bussotti.
1964	Robert Rauschenberg wins the Gran Premio at the Venice Biennial. Consecration of New Dada and Pop Art.	Terry Riley brings out the record *In C* which opens the way to minimal music, John Coltrane records his album-manifesto *A Love Supreme*.
1965	Warhol entitles his solo exhibition at the Philadelphia Institute of Contemporary Art "An Art Exhibition without Art". Rosenquist paints his 26 metre wide *F-111* which is shown at the Jewish Museum of New York and the Moderna Museet in Stockholm.	On his album *Fire Music* Archie Shepp treats pieces like Duke Ellington's *Prelude To A Kiss* and Tom Jobim's bossa nova masterpiece *The Girl From Ipanema* as Pop Art, critically retransforming them. John Coltrane approaches free Jazz with the record *Ascension*.

| 1966 | Claes Oldenburg produces "soft" sculptures in yielding fabric: gigantic telephones, typewriters, toasters, WCs, lipstick holders and toothbrushes. Peter Blake and Richard Hamilton design some Beatles album covers. Warhol produces several Velvet Underground albums, also designing the covers. | Frank Zappa and the Mothers Of Invention release their first album *Freak Out!* The Rolling Stones bring out the first album featuring only their own compositions. |

| 1967 | Roy Lichtenstein grants an important interview to Raphael Sorin in which he says "I owe my style to comics but not my themes." | Roscoe Mitchell's Art Ensemble is set up in Chicago with Lester Bowie, Joseph Jarman and Malachi Favors. They mix jazz, theatre and poetry, record pieces for solo instruments and, in rehearsal, a long re-elaboration in 1968 of *Oh, Susanna*. Bowie will become the greatest re-elaborator of songs in a Pop Art key, in accordance with the aesthetics of *Great Black Music - From Ancient To The Future*. Muhal Abrams releases his first album under his own name, *Levels And Degrees Of Light*. The album *The Velvet Underground & Nico* comes out with an Andy Warhol multiple on the cover, a banana that can be peeled. The Rolling Stones play the Warsaw Palace of Culture, the only rock concert "behind the curtain". Thousands of kids clash with police. The Doors cut their first record. |

| 1968 | On the campus of Yale University Claes Oldenburg installs the sculpture *Lipstick – Ascending on Caterpillar Tracks*, in which the association lipstick-tank appears, typical of the artist. The work is an ironic tribute to Vladimir Tatlin's *Monument to the Third International*. | The Beatles bring out the double album known as *The White Album*, with their first approaches to electronics. Other releases are *The Songs Of Leonard Cohen*, Riley's *Rainbow In A Curved Air* and *Three Compositions Of New Jazz* by Anthony Braxton. Caetano Veloso, Gilberto Gil, Os Mutantes, Gal Costa and Nara Leão change New Brazilian Popular Music, presenting the Tropicalist movement with *Tropicalia ou Panem et Circences*. Release of *Cheap Thrills* by Big Brother and The Holding Company with a splendid cover by Robert Crumb and featuring the voice and personality of Janis Joplin. The Soft Machine's first album offers the first avant-garde Rock-Jazz and the art of Robert Wyatt. *The Dock Of The Bay* consecrates the glory, now dramatically posthumous, of Otis Redding. |

1969 TAKI 183 is the first graffitist to achieve fame in New York. He sets out from 183rd Street, hence his tag. With marker or spray he "signs" houses, public buildings, benches, underpasses and collective areas of the Subway. Emergence of the tribes of Writers, the new Kids of New York, very young blacks and Puerto Ricans from the suburbs.

With *In A Silent Way* and *Bitches Brew* Miles Davis introduces electronic jazz. On *Live!* the Grateful Dead present what will become their most famous composition, *Dark Star,* right in the middle of the psychedelic era. Paul Bley and Sun Ra begin to use the Moog synthesiser in experimental jazz.
In Bethel, near New York, the first and biggest pop rock festival of all time is organised: Woodstock. Intended as a simple provincial rock festival, it unexpectedly draws more than 400.000 young people for three days and nights. The musicians include Joan Baez, The Band, Blood, Sweat & Tears, Paul Butterfield Blues Band, Canned Heat, Joe Cocker, Creedence Clearwater Revival, Crosby, Stills, Nash & Young, the Grateful Dead, Arlo Guthrie, Jimi Hendrix, the Incredible String Band, Janis Joplin, Jefferson Airplane, Santana, John Sebastian, Sly and the Family Stone, Ten Years After, The Who and Johnny Winter.

1970 The first metropolitan tribes start living on the street and Street Art comes into being in New York. Exponents include STAY HIGH 149, PHASE II, STICH I, COOL STAN, SNAKEI, BARBARA 62, JULIO 204, SUPER KOOL 223. This first generation of street artists write on walls and in trains in order not to be ignored. They don't follow the media and don't think that they are creating even transitory works of art. All the signs of Street Art refer only to the memory of those who have seen them, and they are documented by very few photos between 1970 and 1975.

The Grateful Dead return to country with the masterpiece *Workingman's Dead*. Popol Vuh and Tangerine Dream release the first albums suggesting a new use of electronics in rock, derived from the "cultured" avant-garde. Analogously to Woodstock, the Isle of Wight, off the coast of Southampton (Great Britain) hosts a festival including the Doors, the Who, Jethro Tull, Jimi Hendrix, Joni Mitchell, Emerson Lake and Palmer, Sly and the Family Stone, Joan Baez and Leonard Cohen. The festival will pass into history as Jimi Hendrix's last public appearance and the last European performance of the Doors with Jim Morrison.

1971 Andy Warhol does the cover for the Rolling Stones' *Sticky Fingers*, a zip that opens up on a pair of men's trousers. Serge Gainsbourg revolutionises French song with *Histoire de Melody Nelson*.

1972 United Graffiti Artists, the first group with a "legal" orientation, inaugurates the first exhibition on 7th December at City College. The animating spirit is Hugo Martinez, teacher and sociology specialist at New York City College. For a brief period the group organises itinerant exhibitions: in 1974 at the Razor Gallery and at the Chicago Science Museum. The group includes S.J.K 171, SLIM I, SPANKY 132, TREX 131, CO-CO 144, RAY-B 954 and CHARMIN.

In London Ornette Coleman records the symphonic suite *Skies Of America*. The Master of Ceremonies who flanks the DJs during Block Parties, the Afro-American neighbourhood parties of the 70's, is soon adopted by the rappers in its abbreviated form MC.

1973 On 26th March the New York Magazine publishes an article by Richard Goldstein, the first to define graffiti as "artistic expression".

Rap, a continuation of Hip Hop culture, explodes in the 70's in the New York districts of Brooklyn, Harlem and the South Bronx. Gang Organisation, later Zulu Nation, emerges.

1974 In the early 70's, on 149th Street in the Bronx, the *Grand Concourse* comes into being where styles are founded and canonised: the first classifications are made, with iron rules on originality and checks made on anybody copying another's style. There are fines for invading others' space. The beginning of loss of anonymity and acquisition of identity. Roles are defined and characters emerge.

Africa Bambaata, one of the fathers of Hip Hop, founds the Universal Zulu Nation in the Bronx, offering an Afro-centric and pacifistic model. The Zulu Kings are formed, among the first to practise breakdance on the streets.

1975 Jack Pelinger founds the *Nation of Graffiti Art*. He gives a warehouse to all the artists and writers. The result is pernicious: an actual creative death in the space of very few months. United Graffiti Artists also closes down.

In July Lou Reed releases *Metal Machine Music*, created by the interaction of two distorters from which the sounds of his guitar issue. Philip Glass releases *Music In Twelve Parts*. Henry Threadgill, Fred Hopkins and Steve McCall release the first record of the trio Air which, side by side with New Jazz, recovers the compositions of Jelly Roll Morton and Scott Joplin. Patty Smith debuts with *Horses*, her photo on the cover by Robert Mapplethorpe.

1976 Street Art, evolution of the great history of graffiti and subsequent to the more general MTA (Mass Transit Art) unites the new emulators of TAKI 183. An actual *TAKI Award* for young artists is later established.

Bob Marley and The Wailers release *Live!*, a masterpiece of Jamaican reggae.

1977		Kraftwerk release the album *Trans-Europe Express,* source of inspiration for the electro-boogie genre brought to the fore by Bamabaata, Planet Patrol, Jonzun Crew, and Newcleus.
1978	Stephan Eins opens *Fashion Moda*, a shop in the South Bronx dealing in post-industrial and post-modern art objects. In Flash Art N° 107-1982 Francesca Alinovi will write: "Fashion Moda is a far from conventional gallery and in no way commercial. For three years it has been flourishing in the most dangerous and ill-famed quarter of New York". Alinovi, a student at the DAMS of Bologna, is the first to introduce Graffiti Art to Italy, almost in real time.	
1979	Between the late 70's and early 80's the graffitists of the South Bronx and Brooklyn emerge, keeping their distance from Street Art to the point of abandoning it. They are convinced that they are producing art and include FUTURA 2000, TRACY 178, BLADE, NOC 167, DAZE and CRASH. Keith Haring and Jean-Michel Basquiat also make their appearance, the latter signing his downtown works with the acronym SAMO. *"Soho News"* prints photos of his work, contributing to his fame.	The Sugarhill Gang's *Rapper's Delight* is the first successful Rap record in the USA.
1980	John Ahearn founds the *CoLab* (Collaborative Project Inc.)	Kurtis Blow achieves success, the first Hip Hop performer to appear on a national TV programme. His album *The Breaks*, brought out by a major record company, sells more than a million.
1981	The Mudd Club opens. The film *New York Beat* by Edo Bertoglio comes out under the title *Downtown 1981* with Basquiat as the main character.	

1982 In Kassel *Documenta 7* presents the Fashion Moda *Boutique*, exhibiting T-shirts, posters and graffiti multiples. In New York Keith Haring presents his luminous panel in Times Square. With Kenny Scharf, Haring organises the *Drawing Show* at the Mudd Club with performances, rap music and breakdance. In March Basquiat has his first solo show in the United States at Annina Nosei's gallery.

Grand Masterflash and the Furious Five release *The Message* which goes straight to number four in the charts. The often accusatory lyrics give birth to a sort of committed Rap.

1983 Success reaches a peak with the exhibition *Post Graffiti* at Sidney Janis's Blue-Chip Gallery in New York and another at the Boymans-Van Beuningen Museum in Rotterdam. Bruno Bischofberger introduces Basquiat to Andy Warhol after his successful exhibition at the Fun Gallery. Basquiat gets to know Andy Warhol better and the latter rents him a studio in Great Jones Street which he uses until his death. Basquiat goes to Milan with Warhol and on his return begins collaboration with him and with Francesco Clemente.

Herbie Hancock and Grandmaster D.ST. create *Rockit*, the first Hip Hop/Jazz crossover. *Cooky Puss* is released, the first single by the Beastie Boys, the first white Hip Hop group. Over the years the Beastie Boys will be one of the most famous groups at international level. Run DMC's first successful single is released, *It's Like That b/w Sucker MC's*, concluding the old school of American Rap and bringing about a new style which will characterise the movement for a long time.

1984 At the beginning of the 80's many exhibition spaces, from the underground to the galleries, show only Graffiti Art. Mel Neulander and Joyce Twobin set up *Graffiti Above Ground* on 14th Street and Hudson and the legendary Fun Gallery opens in the East Village. Nightclubs open, descendants of the dance wave discos. Underground music venues are the revelation of the 80's. Keith Haring, just arrived in New York, organises exhibitions at the Mudd Club and at Club 57, creating alternatives to the big galleries. ABC No Rio is a collective open space in the backroom of a rundown shop on the Lower East Side. In Italy the first event dealing with graffiti is *Telepazzia* at the Galleria d'Arte Moderna in Bologna during the sixth week of the performance organised by Alinovi, Barilli, Daolio and Mango.

Miles Davis releases *Decoy* with his own drawings on the internal cover, doing the same the following year with *You're Under Arrest*. Rick Rubin and Russell Simmons set up Def Jam Records, a label that will feature some of the most famous performers on the American music scene.

| 1985 | The years between 1985 and 1989 are known as the diehard era in New York. The Transit Authority carries out strict controls on the subway lines, sparking off an actual "graffiti war". | Run DMC release *King Of Rock*. The album grafts Rap onto Heavy Metal, erasing the demarcation line between apparently hostile genres. |

| 1986 | | Run DMC collaborate with Aerosmith on a cover version of *Walk this Way*. |

| 1987 | Andy Warhol show in Milan dedicated to Leonardo's *Last Supper* at the Refettorio delle Stelline, an exhibition space opposite the Basilica di Santa Maria delle Grazie which houses the original painting. Andy Warhol dies in New York. | Public Enemy release their debut album *Yo! Bum Rush The Show*. Their style is decidedly political and accusatory. Appearance of NWA (acronym of Niggaz With Attitude), outstanding among them being Dr Dre. Their style is re-baptised *Gangsta Rap*. |

| 1988 | Basquiat dies in Brooklyn where he was born in 1960. | Public Enemy bring the genre onto the barricades of struggles between rival gangs. They promote the creation of an opposing black power. |

| 1989 | | Queen Latifah is the only woman to find a place in rap music, a scene clearly hostile towards them. |

1990 Keith Haring, born in Kutztown in 1958,
 dies of AIDS in New York.

1990- The decade is characterised by development
2000 of various styles within the Hip Hop move-
 ment. The split between East and West Coast
 leads to the demise of outstanding figures
 such as B.I.G. and Tupac Shakur. The genera-
 tions proceed, bringing forth personalities
 and groups who make their mark on the
 history of music: De La Soul, Jungle Brothers
 and KRS-One, Snoop Doggy Dog, LL Cool J,
 Dmx, Ice Cube, Ice T, Method Man, Busta
 Rhymes, Wu-Tang and Missy Elliot. The end
 of the decade sees the emergence of Eminem
 who in 1998 signs his first official recording
 contract with Dr Dre.

 The various blends of Hip Hop reach Italy. The
 culture spreads mainly on the circuits of the
 centri sociali and Posses, resulting in groups
 like Onda Rossa Posse, Assalti Frontali and
 Sangue Misto (formerly Isola Posse). There are
 experiments fusing Hip Hop and electronic
 music such as Almamegretta, Casino Royale
 and 99Posse. Subsequently a "commercial"
 current develops with Articolo 31, OTR and
 La Pina and Sottotono and Area Cronica, the
 only attempt to create a crew and label along
 American lines. With constant polemics
 some detach themselves from this genre: the
 Hip Hop of Neffa e i Messaggeri della Dopa, DJ
 Gruff, Frankie HI-NRG, Fritz Da Cat and Alien
 Army. A self-produced underground genera-
 tion also emerges that includes figures like
 Joe Cassano and Fabri Fibra.

Valerio Dehò

Valerio Dehò, an art critic, has been curator of kunst Merano arte since 2002. He studied in ologna with Anceschi, U. Eco and G. Sandri. He was commissary of the last Rome Quadrennial in 2005. e teaches Aesthetics at the Sassari Academy of Fine Arts.

Uwe Husslein

Uwe Husslein, a great connoisseur of 1960-70's musical culture and poster production, runs the okPop/JFC Medienzentrum in Cologne. In 2005 he was curator of the exhibition "Got the Look Graphik er Popmusik" at the Museum für Angewandte Kunst in Cologne.

Fabio de Luca

Fabio De Luca, journalist and DJ, writes for Rolling Stone Italia, for the monthly XL (La epubblica magazine), for IO Donna (Corriere della Sera magazine) and for Hot. He has hosted various rogrammes for RAI Radio 2 and has written several books, notably "Mamma voglio fare il DJ" (2004) and Discoinferno" (2006).

Marco Mancassola

Luis Böde, pseudonym of Marco Mancassola, is a talented 30 year old writer, a careful observer f the multifaceted world of youth. In 2001 he became a literary cause célèbre for the small ublishing house that brought out his first novel "Il mondo senza di me". His other works include Last Love Parade". "Storia della cultura dance, della musica elettronica e dei miei anni" (2005). e lives and works in London.

Aaron Rose

An internationally famous writer and independent curator, he currently lives in Los Angeles. rom 1992 to 2002 he was director of the Alleged Gallery in New York from which important artists like arry McGee and Chris Johanson emerged. In 2006 the Milan Triennial hosted his itinerant exhibition Beautiful Losers".

Sound Zero
Art and Music from Pop
to Street Art

09.09.2006 – 07.01.2007

Merano arte
edificio Cassa di Risparmio
Portici 163
I - 39012 Merano

Damiani Editore
via Zanardi 376
40131 Bologna, Italy
tel. +39 051 6350805
fax +39 051 6347188
info@damianieditore.it
www.damianieditore.it

Translation
David Smith

Design and lay-out
Andrea Muheim
granitweb.it, Lioba Wackernell

Printed in August 2006 by
Grafiche Damiani, Bologna

Thanks to
MUMOK Museum Moderner Kunst Stiftung Ludwig Wien, Vienna
Fondazione Marconi, Milano
Fondazione Morra, Napoli
Collezione Giorgio Casoli, Perugia
Collezione Massimo Benedetti, Bolzano
Collezione Carmen Bazzoli, Bolzano
Collezione Nicola Danè, Milano
Collezione Ernesto Esposito, Napoli
Collezione Giulio Galgani, Arezzo
Collezione Uwe Husslein, Colonia
Collezione Klaus Knop, Lünen
Collezione Pietro Mellini, Bolzano
Collezione Carlo Palli, Prato
Collezione Donato Rosa, Napoli
Galleria Les Chances de l'Art, Bolzano
Galleria Studio Cristofori, Bologna
Galleria Marella Arte Contemporanea, Milano
NT Gallery, Bologna
Galleria Pack, Milano
Galleria Perugi, Padova
Claudio Poleschi Arte Contemporanea, Lucca
Galerie Thaddaeus Ropac, Salisburgo
Studio d'Arte Raffaelli, Trento
Galleria Sorrenti, Novara
Sergio Tossi Arte Contemporanea, Firenze

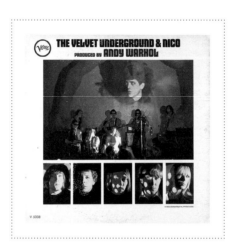

Andy Warhol
The Velvet Underground & Nico
1971
Verve Records, USA (back)
Courtesy Klaus Knop